I would not paint a rock
A face or brook or trees
Mere semblances of things
But something more than these

I would not play a tune
Upon a sheng or lute
Something that did not sing
Meanings that else were mute

That art is best which to
The souls range gives no bound
Something besides the form
Something beyond the sound

LI PO

HSIEH HO

triumph in color

Palette on Glass / 1967

 Phoenix Publishing, Canaan, New Hampshire

triumph in color

the life and art
of
Molly Morpeth Canaday

FRANK H. CANADAY
with art commentary by
JANET PAUL
Art Librarian, The Alexander Turnbull Library, Wellington, New Zealand

Canaday, Frank H. 1896-1976.
 Triumph in color.
 Includes index.
 1. Canaday, Molly Morpeth, 1903-1971. 2.
Painters—New Zealand—Biography. I. Canaday, Molly
Morpeth, 1903-1971. II. Title.
ND1108.C36C36 759.9931 76-30866
ISBN 0-914016-38-5

Printed in the United States of America
Production by Courier Printing Co., Inc., Littleton, N.H. and
Lane Press, Burlington, Vt.
Binding by New Hampshire Bindery
Design by A.L. Morris

Contents

. . . in the end, a triumph in color

A STRANGE terminal-type phrase for the beginning of a preface, but not strange as the introductory words about the life of a woman of unusual charm and taste, of unusual grace in dealing with humankind, and of unusual ability in contributing to the beauty of life for all about her! She was extraordinary also in maintaining her own principles and style and possessed a saving flexibility in her approach to all phases of life.

So, a summary of the principal contributions she made through art to the enrichment of her world is a suitable start to this story about her: "In the End, a Triumph in Color."

After a final illness took Molly from me at the beginning of 1971, I received a letter from Mrs. Rose Hart Betensky, then president of the National Association of Women Artists. It was an invitation to enter one of Molly's paintings in the association's annual exhibition of that year as a posthumous tribute to a cherished member who had twice been awarded an important prize. She had won these honors in competition with the

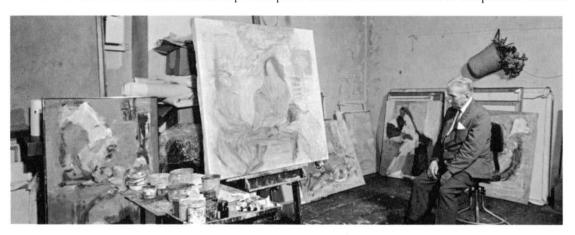

thousands of other canvases submitted for acceptance each year for the Women's Annual Exhibition in the National Academy Galleries on New York's Fifth Avenue.

It was only with this incentive that I finally made my postponed and reluctant first visit after her death to Molly's studio in Manhattan's garment district. I went there with her friend and studio partner, Mrs. O. Edmund Clubb, and we found, stacked against the walls of Molly's section of the large three-person studio, a score or more of her late paintings. Many were of important size and character but I had never seen most of them before! It immediately became apparent that here I would find the most appropriate painting to represent her mature achievement, but the first commentary that came to my mind, as I slowly turned each canvas forward for examination, was: "In the End, a Triumph in Color!"

It was evident that, in the last months of failing health, when on doctor's orders she was permitted to go to her fourth floor studio only on condition that she mount the stairs a few steps at a time, carrying a cushion to

rest at each stop, she must have put forth a concentration of vigor gathered for her greatest most determined effort.

In comparison with the earlier work of Toledo days and even with some of her work of recent years that I had seen, these paintings seemed to me, as to her fellow painter Mariann, to be an expression of her innate color sense. They were also representative of all she had learned about structure, dealing with space and composition—All she taught herself about selectivity and elimination—and all that her unfailing taste had contributed to every painting she produced, early or late. In the end, it was not only "a triumph in color," but a complete application of all the complex elements of technique which had been made gradually her own.

Consequently it was with difficulty that we narrowed the choice to three canvases upon which Mrs. Clubb and I mutually agreed we should let our consideration for final selection rest. Suddenly, then, it was as if Molly herself indicated which of these we were to choose. We discovered that the most colorful of the three bore a signature in its lower right-hand corner so unusual that it struck me with astonishment and a sense of its having special significance. Throughout her years of painting it had been usually only when a canvas was to be entered in an exhibit that Molly would be persuaded to add her signature. It was often done obscurely, in small script, and in a color so similar to that of its background area as to be barely visible.

Here an astonishing contrast, on one of the most vigorous abstracted presentations of a studio interior, was her name in bold capital letters an inch-and-a-half high — MOLLY CANADAY. Instantly it was as if she had smiled at me across the void and said, "This is the one I would have you choose!"

I turned to Mariann with this thought on my lips, and at the same moment her keener eyes discovered higher up on the canvas the old, familiar signature as well, in the habitual small script, barely visible in red-orange paint on an orange background. Not only had Molly signed the painting as if to prepare it for exhibition, she had added below a bold endorsement in "caps" as if with a sense of triumph in achieving, at last, the mastery toward which she had been striving for nearly forty years!

This painting, to which I gave the title, *Studio on Twenty-fifth Street,* went on display prominently in the 1971 Annual Exhibition of the National Association of Women Artists. Later the Toledo Museum of Art reproduced it in full color as a leading feature of the catalogue issued for the extensive retrospective exhibit accorded Molly's work in March, 1972.

Of the forty-odd paintings selected for this show by Robert F. Phillips, Curator of Contemporary Art of the Toledo Museum, many of the most mature were among those discovered stacked obscurely against the walls at 100 West Twenty-fifth Street. A number of these, including the one exhibited in the Women's Annual, are reproduced in the portfolio section to convey an initial impression of the quality achieved during a lifetime of effort.

Frank H. Canaday

"Cleftwaters" May 1976

Molly Morpeth Canaday
...a portfolio

*Detail of Abramofsky's
portrait of Molly Canaday*

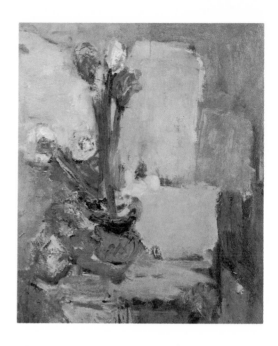

Flowers Against Abstract Shapes / 1969

Interior with Green Plant / 1964

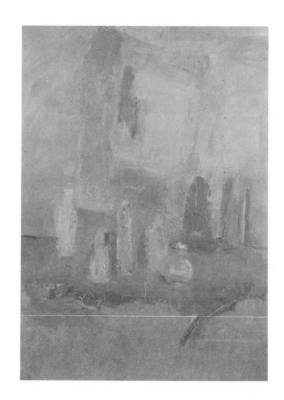

Bottles II / 1966-67

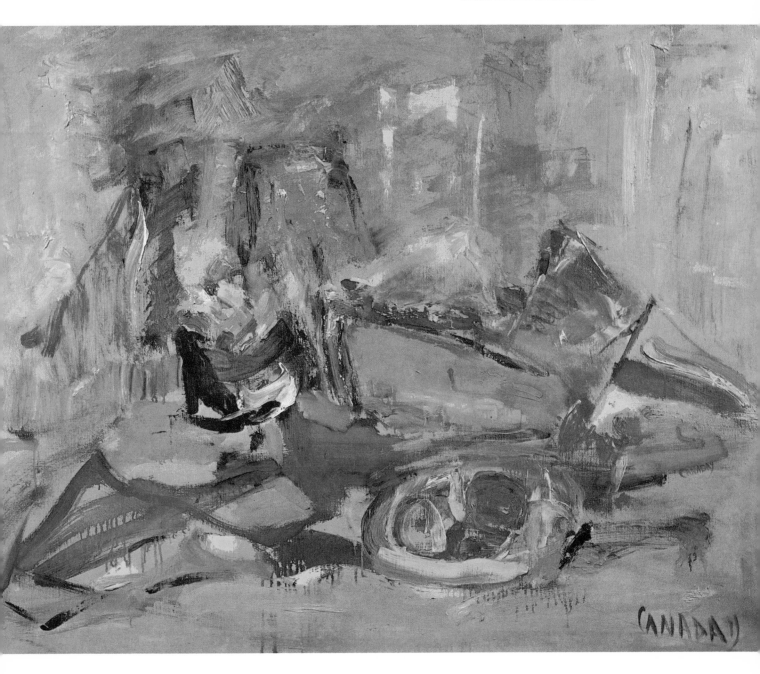

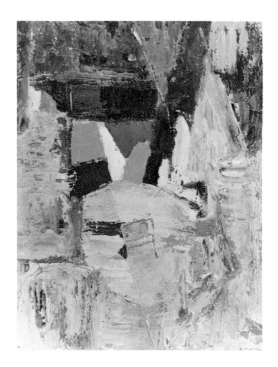

Late Abstract

Garden Reverie / 1967

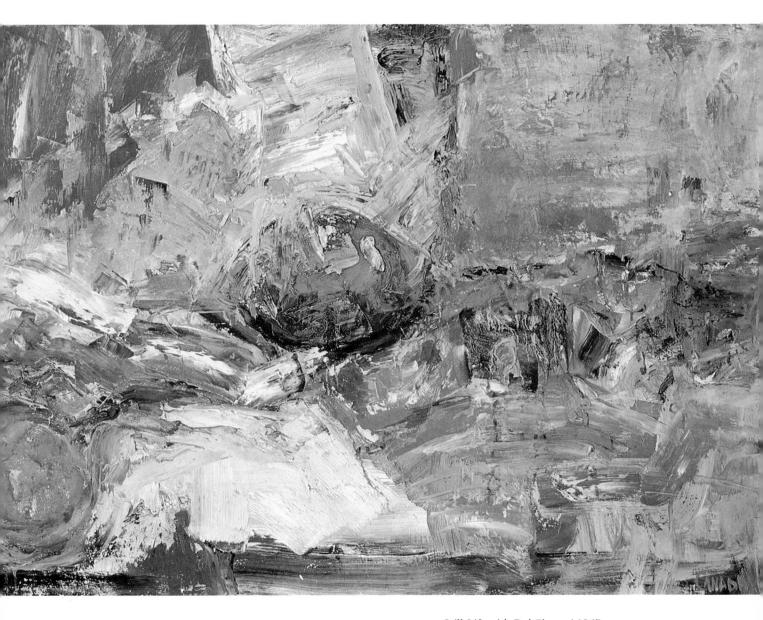

Still Life with Red Flower / 1967

Still Life with Blue Vase / 1966　　　　　*Abstraction - Sun Series*

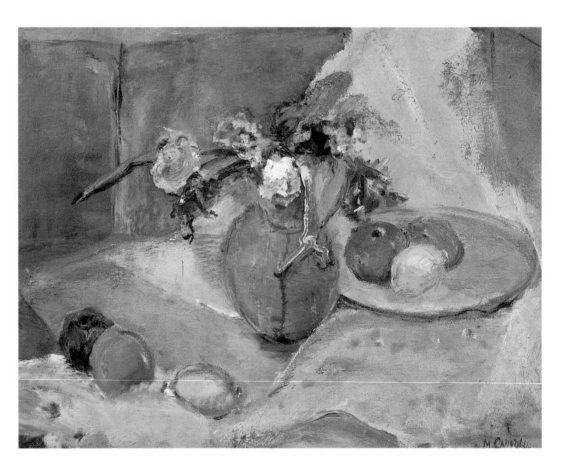

Blue Vase with Flowers / 1969

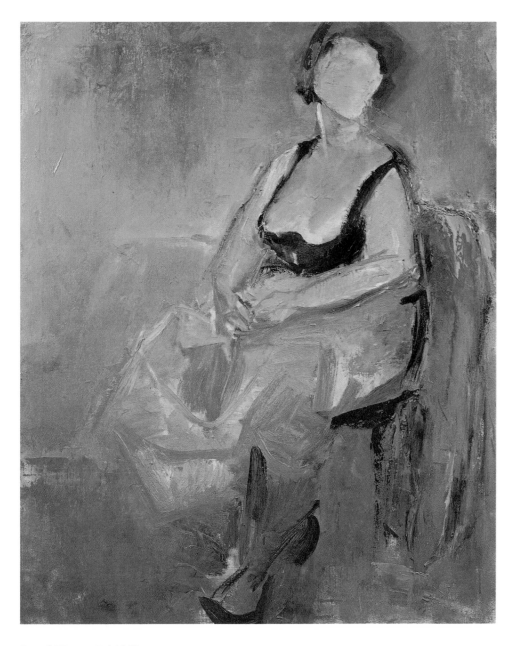

Seated Woman II / 1969

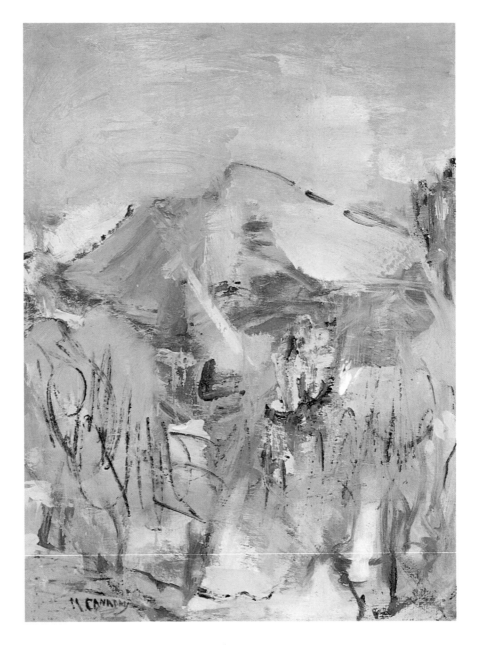

Mount Ascutney from Hill on Rice Farm / 1965

triumph in color

氣韻生動

1

From These Beginnings

WE MET on the Tasman Sea, on a steamer bringing Molly and her parents home to New Zealand after a sojourn for her health in Australia's bright mid-summer. Ours was a meeting in the narrowest niche of time and the earth's breadth, as if the business trip taking me around the world had been planned by fate with no other intent than to place me aboard the old *S.S. Ulimaroa* on that particular December voyage of 1928. At the end of my journey all the business connections I had established during my fourteen months of travel were to crumble in the economic crash of 1929.

During my brief stay in Wellington, though I saw Molly only twice, at a luncheon in a restaurant, and one evening at her sister's home in her family's presence, those two meetings were to establish between us some communication, indefinable and indestructible. It was destined to hold, at first faintly, and finally, firmly against all the tides of misfortune which the world situation was to impose. After long correspondence I saw Molly again in London in 1932, and that December 17 we were married in the United States.

Before continuing Molly's story, linked with my own, an account of her activities and background during her youth and adult years in New Zealand is pertinent. Her acquaintance with and initial participation in creative art constituted what I shall call the preliminary period of her life as an artist.

Out of an artistic spirit nurtured in childhood and youth in New Zealand came a creative incentive toward painting in America. Examples of this progression toward maturity are reproduced on the pages of this account of our life together.

Molly's Childhood

Molly received her elementary education near her home in a school conducted by a Miss Frances.

"I was happy there," she told me, "mainly because a number of little girls from our neighborhood became congenial friends."

The loving consideration that she received at home in that period is revealed in a circumstance she once related to me, created by a childish adventure with one of these young friends in the Morpeth kitchen. There, in meticulously clean conditions, they managed to bake some scones which, after their diligent kneading, came forth from the oven a dust-gray, and yet were received by her mother with every evidence of welcome as a contribution to her tray of delicacies served at her high-teas for guests.

From Molly's sister Nona I learned that these "at homes" occurred regularly, as she remembered, every second Thursday. It was in the period when reasonably-paid help was available in most homes as a

friendly and honorable service.

As Nona reported the high-tea occasions:

The drawing room fire was lit; all the glass and silver had been polished till it glistened, and the elegant afternoon tray embellished by Molly's gray scones was served by a maid in black dress and frilly white cap and apron!

Sometimes we young people were allowed to come in for a little while, but not for long–till the visitors were gone. Then we were allowed to finish whatever sandwiches and dainties were left.

Nona contributed also a story about her small sister at even an earlier age, in infancy: *Before Molly could walk, I still recall, she used to propel herself about their home place on a little 'sit upon' vehicle pushed along by her feet. Whenever she had disappeared outside, we knew exactly where to look for her, for she would go at once to the greenhouse, and when we found her there she would make little clucking sounds, with her eyes fixed firmly on the colorful bunches of grapes.*

This had been in an early house surrounded by an extensive garden. Later her parents moved to a larger house more centrally located on Wellington Terrace, high behind the city. Molly's education then continued through its later elementary period at a school again near her home and conducted by a Miss Baber. "Here," Molly told me, "I made congenial acquaintance with other girls of the neighborhood, some of whom became lifelong friends."

The High School Years

At high school age she was entered at a school for secondary education which had the patronage of a Reverend Samuel Marsden, from whom it came to be known as the Marsden College School or, more familiarly to Molly's family and friends, simply as "Marsden."

Asked once about the nature of the courses given there, her reply at first was simply an indeterminate, "Oh, the whole range of the usual secondary school subjects!"

However, in later references to this period of her education, it became evident that her interests had centered mainly upon classes that led into a wide reading of English literature, as well as of French and other European classics in English translation, and along with this a fairly thorough introduction to the French language. She also spoke of having received at Marsden some instruction in art history and amateur practice in drawing.

Though she never included mention of any training in elocution after graduation, I learned that she had attended a course of such practice in speaking then offered by a Miss Maltby in her home on Bolton Street, near the Terrace House. There, Nona told me recently, "the houses resembled those of New Orleans, with their embellishing iron fretwork." She described both Miss Frances and Miss Maltby as "gentlewomen, quite Victorian in flavour."

IN SOME of my late talks with Nona about this early period of the three sisters' lives, she emphasized that though she herself was seven years and four months older than Molly and that this had limited to some extent her youthful contacts with the little

latecomer, "she was always someone you couldn't help loving."

I was born in 1896 during Queen Victoria's reign. Molly on the other hand was, by her birth in 1903, properly to be considered an Edwardian of the twentieth century. Nevertheless, we both really shared a very Victorian background in the earliest family house called 'Ercildoune' and in its successor that father build on The Terrace. This too he gave the same name, I suppose from some attachment he had from his wide reading which had included many of Sir Walter Scott's novels.

The Terrace House and most of its neighboring ones she remembered as large, "each with a drawing room, a morning room, and offices, pantries, sculleries, washrooms, etc., and a number of bedrooms."

In further reminiscences shared with me, Nona disclosed that in both their Ercildounes, "my mother had the drawing rooms papered in a primrose colour, with a fringe of purple irises around the top and long deep-violet satin curtains.

"She loved colours," Nona added, "and my memory is of a sumptuousness throughout, with many pictures, mostly originals. I still have one painted by father dated June, 1886."

Influence of Molly's Father

Molly often mentioned to me her father's love for pictures. "And he collected a number that he added to those he had inherited," she said.

Among them was one by Rhona Haszard, my second cousin, born in Wellington. She went later to work overseas and gained considerable international distinction. Her name is still often linked with that of Frances Hodgkins, another New Zealander from Dunedin, who became appreciated through the world for her work done mainly in London and Europe. She did a lot of watercolours of New Zealand and other backgrounds, and father owned one of these that hung in our rooms along with one or two of his own.

Molly also owned one of these and all our married life it hung in our bedroom or finally over the chest of drawers in Molly's dressing room. Writing on the back told where she had painted it near a river in the South Island.

"Though my mother participated at times in father's picture collecting," Molly said, "her chief art interest was music. She had come from a large family in which her parents and brothers had formed and maintained their own orchestra. She had a glorious contralto voice."

To a similar account Molly had added early during our life together that her father "on the other hand, couldn't sing a note in tune."

"Nevertheless, he liked music," she assured me, and said she believed that he had "entered quite happily into the musical evenings which became a feature of our lives, particularly when we went to live in The Terrace House."

Friends came frequently to play instruments and sing in our home, and I can remember when we were small how we used to lie on our stomachs on the second floor gallery that ran around the hall where we could look down through the banisters and see and hear quite a bit of what went on

below. Later we were encouraged to join in the singing and playing, and now I almost hate to think what a lot must have been spent on music lessons for us, and taken for granted, without any really sustained effort to make any of it effective.

Of her father and his participation in all this, Molly remarked often that his chief cultural devotion was to literature, and told how he would read books, stories, and poems to them for as long as they would listen.

Nona also mentioned one special memory of his excitement when he first read Francis Thompson's, "The Hound of Heaven."

I fled Him, down the nights and down the days;
I fled Him, down the arches of the years . . .

"He followed us around the house reading it aloud," she said, "as if it were the most marvelous thing he had ever discovered in his lengthy perusal of his books.

"It is a rather wonderful poem," she conceded, "but poor 'Farvie,' I'm sure we didn't respond enough! All these things made the climate and atmosphere which influenced us as we grew up."

Apart from such occasional intensive demonstration of his desire to share with his family his delight in his discoveries of choice poems and passages, Molly spoke often with fond remembrance and lasting appreciation of their frequent evenings by the fireside when he read in a calm and leisurely vein to the family group. Molly's literary interests initiated by her courses at Miss Baber's and Marsden were encouraged by the easy availability of her father's collection of the world's best books that lined his broad library walls, shelf upon shelf, from floor to ceiling.

She derived valuable cultural benefits from her father's art interests and art collecting. He had established an independent accounting organization early in his career and administered its operation until it was acknowledged as the nation's "best in the field." Home reflections of his firm's involvement with the financial affairs of its many important clients naturally gave Molly some practical familiarity with the patterns of the business world. She was also impressed with the recognition accorded her father as a serious, amateur watercolourist and the resulting enlistment of his financial counsel for many years as honorary auditor of the New Zealand Academy of Fine Arts.

He also brought into Molly's home life some knowledge of civic affairs reflected from his membership in the Wellington City Council. Her mother's long and active participation in the Young Women's Christian Association, with her eventual election to several terms as its national president, was also impressive. Thus, in each of her parents, Molly had an example of the successful combination of family life with other useful activities and responsibilities.

MEANWHILE, her final formal educational approach in her homeland to a life awaiting her in an American future came with her registration at the Wellington Technical Institute in lecture courses and life classes. There she had extensive practice in drawing and modeling from the mid-twenties into 1931. This was at a time, however, as art librarian Janet Paul emphasizes, during which New Zea-

A
Continuing
Art
Commentary
by
Janet M. Paul

Molly Morpeth Canaday, a New Zealander whose
forebears were Scottish, was born in Wellington in 1903
and grew up in its British frontier society eleven
thousand miles, and—in the nineteen-twenties—
a six-week journey from London, its cultural centre.
New Zealand was (as people were fond of repeating)
a young country. It looked back nostalgically and re-
spectfully at the Old Country which Molly Morpeth's
parents undoubtedly referred to as Home.
In the years of her girlhood New Zealanders were loy-
ally British (had not forty-three percent of
men of military age enlisted and 18,500 died in the
1914-1918 war?). As New Zealand geared its fat-lamb
and wool production to the needs of Britain,
its people continued to use British modes as models in
education. The art schools and art societies, formed
in two decades following 1870 in each of the four
main cities, were British in pattern.
Exhibitions, discussion, encouragement of talent and
a conservative regulation of painting tech-
niques were relegated to the art societies.
The Wellington in which Molly Morpeth grew up
had claimed a misleading preeminence in
art by forming in 1889 a society with the title of The
New Zealand Academy of Fine Arts, but no
specific school of art had been established in that city.
In the art galleries there were no masterpieces of
European painting, neither modern nor old.
New Zealand had no rich collectors to endow them.
The nearest Molly Morpeth could have
come to the Old Masters was to study
an historical collection of etchings which included ex-
amples of Mantegna, Durer, and Rembrandt.
Although she might have known a range of English
watercolours, she could not be said
to have had any breadth of visual education from
works of art. She took with her to America an inno-
cent eye, some experience of drawing
and modelling, a sensibility formed by the lively
variety of her native landscape, and her fam-
ily-fostered delight in gardens.
The interest of this book is the well-documented
development of a modest painter. Her work
mirrors the responses of an alert sensibility to the
newly-seen masterpieces of Western
Europe, to contemporary painting, to discussions,
events, and individual assertions of artists of
the New York school which produced a

land was providing art students with only faint tremors of interest in the so-called "modern" movement. Molly would have had at best only a few examples of contemporary styles imported by those artists and art teachers who came into the country from England and Scotland.

It may be noted here that during Molly's visit to England in 1932 one of her erstwhile instructors at the institute learned she was to marry and live in America. She shrugged with resignation and said, "That's what almost inevitably happens. Occasionally you get a very promising student and then promptly lose her!"

"That is How I Feel"

In Nona's opinion Molly certainly showed talent.

To judge by the things she made for the garden at Hutt (the family's country estate), her nature seemed a serene one. However, I remember well that, after I had married and was in Wellington for a short visit, a number of us went on a motor drive up the west coast road, Molly included. This took us over Paikakariki Hill, rather long, very steep, and windblown. Part way up the hill there was a tree which at that elevation had never got very tall. With its back turned to the wind all its life it was growing very nearly horizontal. 'Wiggie' (a family pet name for Molly) looked at it and said, 'That is how I feel.'

It was a remark I have never forgotten for she had always responded warmly to our treatment of her as a person beloved by us all. In material things and in most ways life seemed to have been kind to her. As I've grown older and thought about it, I've come to the belief that this chance remark indicated she must have lived an inner life about which little or nothing was ever revealed to the rest of us.

Since Nona told me this I have pondered its significance, remembering Molly's mentioning all through our life together how her aunts, uncles, and cousins made up a complex and extensive family social life. Although she gave every evidence of having been fond of them, it finally occurred to me that an obligation to reciprocate the affection poured upon her from every side may have denied her the opportunity to nourish an obscure early instinct for creative artistic expression and achievement.

Nona attempted no speculation as to the meaning of this incident but noted, "This kind of remark could be made at times by most human beings, but with Molly the depth of feeling she expressed in comparing herself with the struggling tree startled me." However, in my mind Molly's statement was to remain a continuing challenge to me—to decide if there lay within it some deep basic significance. For this I had no definite concept at this point in her history nor any conjectures that would have a valid place here. The conclusions concerned with this came to me convincingly only as I reviewed our life together after Molly had departed from me. I realized that an early sense of a vague frustration had probably aided her in dealing successfully later with the complexities of her years overseas.

Nona, without further reference to her own surmise, added one more comment perhaps intended as pertinent to the matter above: "I never remember Molly's getting into a temper except on one point: she could never tolerate injustice to others and was capable of flying out in their defense in no uncertain terms."

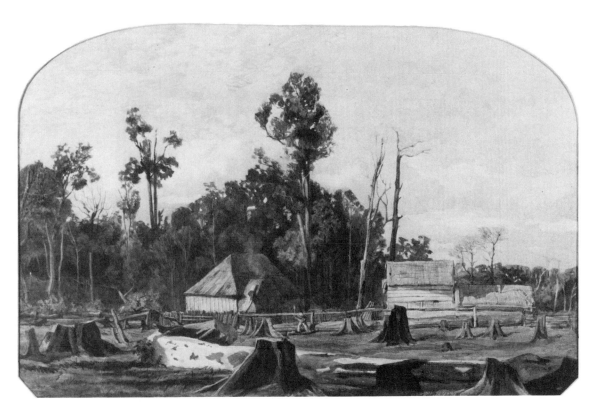

*distinct and recognizable American art.
What was her visual background? Primarily the light
and landscape of Wellington: white wooden
harbour city climbing hills where within
minutes of the main streets gorse and lupin, pohuta-
kawa and daisies flowered. Her family
background had exposed her to painting. She
had grown up in a house hung with landscape water-
colours, some sentimental,
picturesque, and others more sophisticatedly
Scottish-derived impressionism taught
in Wellington at the turn of the century
by James Nairn.
Examples of a more detached and unromantic
accuracy of drawing and colour in New Zealand land-
scapes would have been the paintings
in the National Art Gallery of a civil engineer,
J.C. Richmond. She might have seen lively
work of South Island watercolourists Alfred Walsh
and Margaret Stoddart or, more
rarely, work of the ex-patriot painters, Frances
Hodgkins, Rhona Haszard, or Raymond McIntyre.*

Landscape by John Constable from the Beauchamp collection (top left) and J.C. Richmond's "Taranaki Farm"

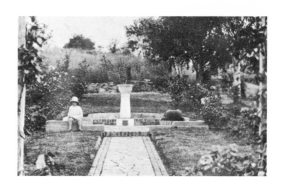

The Hutt Valley Estate

Though Molly often mentioned the numerous social contacts with family and friends, it was always in a spirit of fond regard and personal enjoyment of the company and its occasions. From Nona and any other contemporary source, there is every indication that her generous characteristics remained unchanged, even when her father's purchase of an extensive rural area some twenty miles up the Hutt River Valley brought added visits. There too Molly and her mother, sometimes with one or both of her sisters, labored in garden

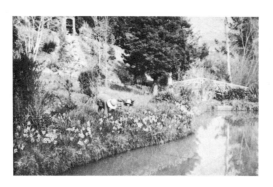

development weekends and often during intervening days. Together they planned and arranged the content and extent of flower beds, both formal and informal, of hedges and lanes, and other elements of that sophisticated creation which was to become one of the first great country places of a Wellington town dweller. There Molly had years of training in color relationships and judgments of the best use of space in landscape composition. (Both of these abilities were to be conspicuously evident

during her early years of painting and helped her progress as she felt her way in that demanding art.)

From the small house built atop the highest wooded land of the estate, Molly could look far down the valley toward distant Wellington. In the seasons when life was based in the city, no doubt her developing habit of observing contrasts sharpened an appreciation of the picturesque character of the streets as well as the varying colour relationships of the suburban borders and the skies over all. This I can validly surmise as she expressed in her letters just such observations of delight during each of her

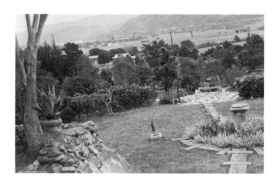

visits home in later years.

As the Hutt Valley estate attracted members of the clan and friends during holidays and weekends, Molly's acquaintance with them deepened and became an ever more intimate part of her life. However, while entering into these assemblages with cheerful enjoyment, later accumulated evidence leaves no doubt that a reticence long-cultivated covered a deep, thoughtful personality increasingly concerned with artistic self-expression.

It is unlikely that she would have heard of Cézanne. Even the influence of the French impressionists was felt at a remove among regular contributors to art society exhibitions. In the late nineteen twenties New Zealanders continued to make pictures innocent of Cézanne's concern with form, of the restructuring of cubism, the fantasy of surrealism, of the free colour of the Fauves, the wit and elegance of the Bauhaus, or the emotional power of the German expressionists.

Students in the four centres drew inspiration from reproductions of Whistler, and from British painters—Forbes, Laura Knight, Brangwyn, Sargent, and Augustus John.

In 1922 a scheme known by the name of its initiator, La Trobe, encouraged associates of the Royal College of Art and other British art schools to take positions in the art departments of technical schools overseas. Some stayed in New Zealand, others found the climate for art too chilling and left after a few years. Molly Morpeth attended the college when one of the most articulate, witty, and polemical of these men was teaching there.

Christopher Perkins was a brilliant draughtsman who had studied under Tonks at the Slade School. Meeting mediocrity head-on he derided the New Zealand cult of picturesque landscape painting, at several removes from Turner. Perkins used for subjects the effect of man on nature—the dairy company buildings, burnt trees, power pylons. His attitude was near to the earlier factual observation and recording of soldiers and surveyors, geologists, and engineers, but there was no recognized New Zealand school of painting or sculpture to which the student like Molly Morpeth could have returned.

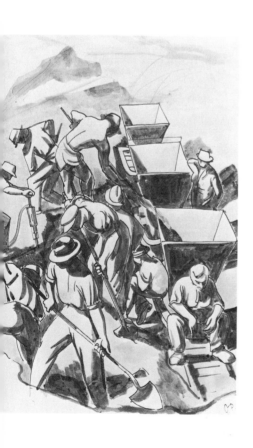

Christopher Perkins' "Road Gang"

IN LOOKING BACK to her teenage years and twenties when her studies and social relationships were based within the home ground of her parents' tall town house, one must not fail to note in retrospect what unanticipated relationships her experiences there bore to the development of her life ahead.

From her third-story window she could look southward across the roofs of Wellington's commercial center and quays and through the distant rock-bordered entrance of Wellington Harbour to a glimpse of the seemingly open sea of broad Cook Strait beyond. Molly saw the arrivals and departures of world shipping at the Wellington docks, principally freight and passenger vessels of the British Empire and its successor Commonwealth nations. Frequently ships of the United States and other seafaring nations were among them. Such scenes kept the young woman mindful of Wellington's position as a crossroads of global traffic.

All this created an early sense of acceptance of the normalcy of marriage overseas, probably involving a citizen of some distant British territory. In Molly's case, however, the range had been broadened to include other countries, particularly America. Molly's older sister Erica had married a New Zealand-born engineer, Alexis (Pat) Entrican. The couple had lived for a year in America while Pat had added graduate study of forestry at the University of Minnesota to his homeland engineering training and experience in various fields. Thus, he prepared for a professional career culminating in his appointment as Director of the New Zealand Department of Forestry.

It became apparent later that impressions Pat and Erica brought home favorably conditioned Molly and her parents toward America and Americans. From this I derived the benefit of a courteous reception as a visitor without a personal introduction but with an apparent interest in their youngest daughter.

The character of New Zealand was aptly
expressed by J. C. Beaglehole
in his "History and the New Zealander,"
from which the following quote is taken:
"New Zealanders were not some original
creation, some sudden and praiseworthy
phenomenon that sprung into complete existence in
the years 1840 or thereabouts.
One sort of New Zealander had already then
physically existed in the country for four or five hun-
dred years; and another sort,
then and later, did not come emancipated from
its past. The settlers wished to escape from
the environment of England and Scotland—
true; but they brought . . . their
'social heritage' . . . compounded of law and
custom, consciously or unconsciously
accepted, of attitudes secular and religious, of ideas
and half-ideas, and words and shades of
meaning, of a thousand crudities and subtleties
pervading, twining round, pushing
and pressing, perceptibly or imperceptibly moulding
and shaping the whole of life. However new
this country, society is old. New Zealand cele-
brated its centennial in 1940. It
might just as well have celebrated Magna Carta,
or the founding of Rome, or Pericles'
speech to the Athenians, or the delivery to
Moses of the Ten Commandments."

Nieces and nephews in the pool at The Hutt

Great Grandmother Morpeth . . . the former Mary Christina
Johnston of Prince Edward Island

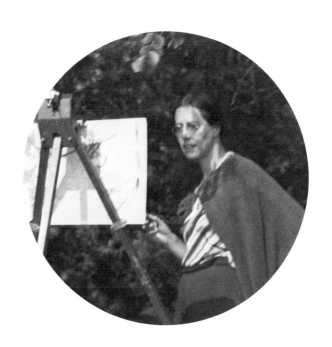

2

The Early Toledo Years

AFTER OUR MARRIAGE in 1932 Molly's developing artistic efforts were fitted into domestic life in a small apartment in Toledo. There, "encouraged" by a fifty percent cut in my salary as the great American depression took a terminal plunge, our modest manner of living continued through most of the decade, Molly cooking and doing most of the housework while I slowly sought my way out of financial straits. However, this is not to imply that our life during this period was narrow or deprived. Our front windows and small outdoor balcony had a pleasant view upon the lawn and gardens of the Toledo Museum of Art across the street, and our life, cultural and intellectual, came to be centered there.

The prestige of the museum's permanent collection attracted passing exhibits of the world's greatest art, both past and present, and its music hall, elegantly named The Peristyle in keeping with the authentic Greek derivation of the building's architecture, brought the great orchestras, superb chamber music groups, and ranking soloists of America and other lands. Talented members of the museum staff and associates of my advertising agency connection provided us an abundant social life during the final throes of the country's prohibition fiasco and beyond.

We were, indeed, inclined to become at once, then continuously, over-busy with a too abundant social life, for my several friends all naturally sought to welcome Molly. The resulting mutual congeniality was soon apparent and frequent interchange of hospitality with our most intimate group gave us too many lively evenings lasting into late hours. Initially we had felt obliged to reciprocate all such invitations, but it was Molly who finally rebelled. She concluded that there must be a curtailment if she was to make any progress in her art classes at the museum and I was to do my demanding work at the office without our both living a life of exhaustion and possible ill health.

After one such party Molly awoke late, feeling cross that her day was shortened. She protested to me: "These parties going on till two and three in the morning are just ridiculous. They show a lack of balance and have no sense of the realities of life. It must stop. You would think that none of us had to do a stroke of work." This vigorous reaction gave me my first intimation that even in this strenuous first year of our marriage Molly was initiating a distinct second period of her life that was to be seriously identified with a career in art. Even if still only subconsciously in her own mind, it was definitely emerging from an amateur phase toward a professional level.

Early Reactions to American Ways

She revealed from time to time some impressions of major or minor differences from those of her homeland which crowded upon her during her first encounters with an American city. On one of her first housekeeping days in America, she told me she had hailed a taxi downtown and instructed the driver to stop at a fruiterer's en route to the address she had given him.

"What's that?" he asked.

"A fruiterer! A green-grocer, of course," she replied.

"Never heard of that either," was his response.

"Well," Molly explained, "I want to buy some vegetables. I'll stop at whatever kind of shop sells them."

She wrote in a letter home about this episode:

It was then that I found the multifarious functions of the American grocer. He has as many sides as a chameleon has colours. He is not only grocer, but butcher, poultrier, fishmonger, fruiterer, baker and pastry cook—everything—even a seller of beer. It's really a grand idea! If you telephone your orders, then you have only the one tradesman to ring. If you do your own marketing, then you have only one parking spot to find.

Before she could regale the family at home with the grocery experience she had another story to add about our drugstores.

"I asked a clerk for the pharmacist," she told me, "and the girl answered, 'What's that, a new book?'"

"If there's anything you can't buy at the grocery store," she wrote to her sister, "I'm sure you would be able to buy it at the drugstore. The prescription department is usually relegated to a dark, remote corner completely lacking in that unctuous, confidential atmosphere of our chemist shops at home."

However, for some little time she kept telling me that, on the phone, grocery clerks still found her British intonation and forms of expression beyond their understanding. On one occasion when we were to have guests for dinner I came home early and found her in a flurry of belated preparation of some chops, when I had been expecting one of her roast beef dinners.

"What happened?" I asked her.

"Oh, the same old thing," she answered, and smiled a bit wearily. "The groceries came late and no roast of beef. I telephoned and found that they thought I asked for a bunch of beets. So I dashed into town before closing time and bought some chops."

Though Molly never consciously changed her voice or manner of speech to imitate Americans, she readily made her idiom understandable to the tradesmen and others of Toledo with whom she commonly dealt. Thus the foregoing were the principal incidents of early confusion in communication which I remembered as somewhat amusing.

*In 1932, when Molly Morpeth and Frank H. Canaday
were married in Toledo, Ohio, "modern art"
was only beginning to be seen in the
museums and art galleries of America. The Museum
of Modern Art had opened in New York
in 1929. The same year the Metropolitan
Museum had inherited the Havemeyer collection
of impressionist paintings and with
it their first examples of Cézanne, Van Gogh,
Seurat, and Gauguin. Newspaper
comment on art in Toledo may have shown as much
complacency or indignation as similar
comment in Wellington, but exhibitions traveled
to Toledo. The painter there was not
cut off from the galleries of New York, Boston,
Washington, Chicago–or Europe–
as she had been insulated by New Zealand's isolation.*

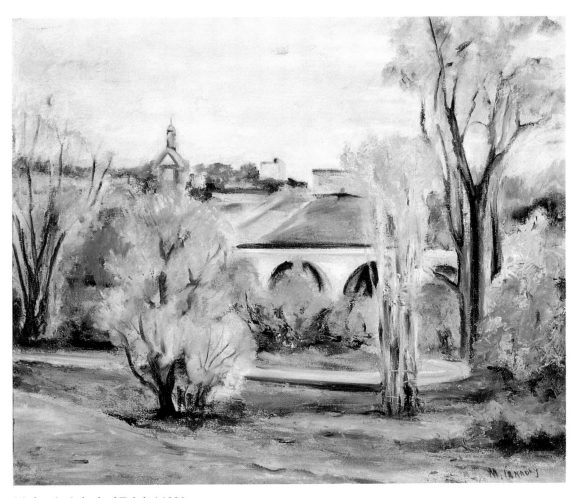

Viaduct in Suburb of Toledo / 1938

APART FROM the gay dinner parties amongst friends, whereby we all maintained a rather cheerful outlook throughout this chaotic period of the Great Depression, it was at this propitious time that the completion of the aforementioned Peristyle of the Museum of Art added superb diversions. One of Molly's first appearances at a public function in Toledo was at the dedication of that auditorium on January 10, 1933, which featured a performance by the Philadelphia Symphony Orchestra with Leopold Stokowski on the podium. The following month the London String Quartet gave several concerts of chamber music. In addition to attending many of these events nearby we sometimes went to Cleveland or Detroit for theatrical or other performances, on one such occasion for a performance of Marc Connelly's Pulitzer Prize play, *Green Pastures,* reflecting the newly arising black-white desegregation issue.

Even with such diversions, if Molly had occasional moments of homesickness during this period, letters she received from her father undoubtedly helped her. I recently found one written to me so illustrative of the heartening quality he put into them that I have treasured it all through life. It is quoted below, revealing in every paragraph the devoted character of one to whom Molly owed, undoubtedly, some of her own winning qualities and taste.

Wellington, New Zealand
March 22, 1933

My dear Frank,
I discover that our mail-boat, the Maunganui, is held up and still here . . . on account of a dispute between her stewards and their chief . . . It is almost incredible, these hard days, that men should, for a purely private quarrel, paralyze mail service or put the passengers to all kinds of extra expense and discomfort . . .
However, it gives me the chance of replying by the same mail to your letter which I greatly appreciated. I am filled with joy at seeing how happy you and Molly are together and how beautifully you each value and appreciate the other's good qualities. I thank you from my heart for the way you write about the wise and wide-trained upbringing my dear wife and I had given her. She is a darling, and a very competent one, too . . .
We are all vastly interested and amused at the reports of Molly's culinary efforts and the effect they have upon you personally and your friends . . .

I am delighted with the artistic and literary circle of friends you have introduced to my Molly and I am sure she will find them most congenial . . .
With much love to you and my Moll-Moll, I am
Ever yours,
Moyie's Daddo

In a further letter home Molly wrote some general impressions of the differences occurring in the United States and in her native South Pacific region due to the reversal of the seasons. Of the discouraging state of the economy, however, she reported little to her family though to us personally the depression was still very much in evidence. Fortunately I remained employed and was able to encourage Molly to continue her study without financial concern.

Progress and Disappointment

With the coming of spring, 1934, Molly could be found regularly in various places sketching the city. Sometimes, inspired by a succession of museum watercolor exhibits, she made some city landscapes in this medium, one example of which is of such a delicate and imaginative spirit that I have kept it on my wall ever since.

Throughout these months I initiated a policy of reticence about probing into her work. It was usually upon her initiative that we had discussion from which I acquired such information as I can record here regarding anything she was learning about the art work she did at home or elsewhere during those early years. I did have occasional glimpses through the pages of one or another of her sketchbooks which she may have left lying at hand and, though avoiding comment or inquiry, my chance inspection showed them to be mainly filled with hasty practice drawings. Amongst these were others more serious, although disclosing through some element that she was still in varying degrees the amateur which she too long appraised herself to be. However, an evening would sometimes come when she would lay before me a page on which was a head, a bust, or a full figure drawing that she felt was evidence of some progress toward maturity.

Going to classes and sauntering afterward in the museum's many display galleries, she passed scores of masterly works and gradually studied closely most of the oil paintings of noted artists, examples of whose work she had never seen in her New Zealand youth except as printed reproductions.

ON GOOD WEATHER WEEKENDS we had tennis, archery, swimming, or country walks. During those weeks when I had to spend days working in our Chicago office I had the compensating joy of letters from Molly which I would never have received but for these seemingly trying absences.

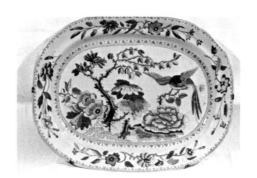

Ceramic "dowry" platter brought from Scotland to our first home in the Plaza at Toledo.

Early Art Training

I look back with some amazement at the skill with which Molly, even in the unfamiliar new status and environment, met the demands of home and social life while also quietly and unobtrusively pursuing her art training or working at intervals outdoors, sketch pad in hand.

Indoors her interest in still life compelled her to face the demands of those infinitely complex techniques which achieve differentiations in the textures of ceramics, fruits, flowers, and other objects. One still life of this period gave an early representation of the thematic combination which was to persist in much of her work, flowers and their ceramic container offering a relationship that she always enjoyed conveying in paint. The bouquet here dominated the painting while the ceramic solidity of the gold-toned bowl and the flowers were in textural contrast with each other as well as with the fabric on the table and the yellow-orange wall.

It would seem that my unpretentious mother also figured in Molly's art as an interesting model. During every visit with us a figure sketch or two appeared that depicted her in characteristic attitudes collectively revealing the essence of her life—devotion to her four sons and her friends. During one of these sessions a weariness crept into mother's face and was registered, as if unconsciously, by Molly's brush. Molly considered this a confirmation of her view that she was not to attempt portraiture, but it evidently impressed her with a need for greater creativity in her figure painting.

Toledo Museum of Art

Certainly the Toledo Museum of Art contributed importantly to Molly's early art training. Opportunity to study the never-ending succession of fine exhibits supplemented the classes she attended in its School of Design. During the last quarter of 1933, for example, the month of September featured an international exhibit of modern architecture which was followed in October by a similar exhibit—this of paintings presented by the College Art Association—with an additional show of French street scenes that had served as public murals. November offered an extensive exhibit of Chinese and Japanese textiles as well as a showing of industrial design, and in December numerous etchings and an exhibition of French 18th century furnishings were on display.

If local appreciation was deficient in its recognition of the size and superior excellence of the museum's permanent collection for a city of Toledo's moderate size (250,000), the prestige of its collection attracted passing exhibits of the world's greatest art, both past and present. Its music hall, then just completed, justified in its attractive interior and excellent acoustics the elegance of its name, The Peristyle, given to it in keeping with the authentic Greek derivation of the building's architecture. Its fame made it possible for the museum to attract great orchestras, opera companies, superb chamber music groups, and ranking soloists of America and other lands.

*Painters are not collectors but they
often give and receive and, when they can
afford it, buy from their contemporaries, work
which is concerned with common
problems or which handles paint or colour
in a way the painter respects. Those
which the Canadays bought show, in each decade,
a preference for European painting.
In the thirties Antoni Michalek,* The Polish
Girl (1934), *Abramofsky's* Portrait of Molly
Canaday *(1937), and a gouache,* Reclining
Dancer, *by the French tapestry
designer, Lurcat, were purchased.*

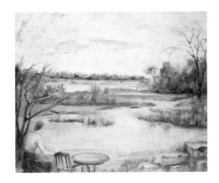

Maumee Valley Landscape / ca 1937

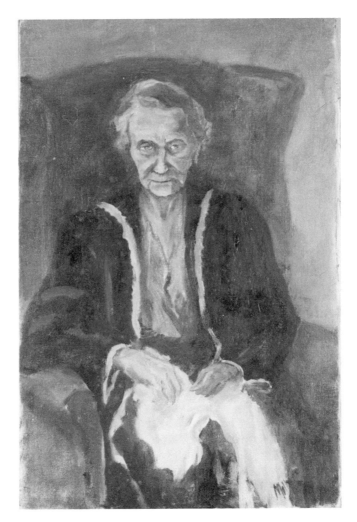

Seated Woman / 1937-38

It may be a matter of interest to many to have a brief explanation of the establishment in this mid-western city of a museum which ranked third with those of larger cities in both operation and superiority of its permanent collection.

The museum was founded in 1901 by Edward Drummond Libbey of the Libbey Glass Company at the suggestion of George W. Stevens. Stevens, who was then thirty-seven, had enjoyed a varied career which had included that of newspaper reporter, columnist, writer, and theatrical manager. He had also published two volumes of verse and exhibited his oils and watercolors on several occasions. A founding member of the Tile Club, an organization of young Toledians interested in the arts, Stevens was urged to present the members' ideas for a museum of art to Mr. Libbey. The glass manufacturer was well acquainted with leading museums in the United States and abroad and sensed the advantages such an institution would have for an industrial community and the fruitful educational relationship it might have with the local public schools.

The founder, who subsequently gave a total of $20,000,000 to the museum, asked George Stevens to take over the new project and make it a success. At the opening of the first exhibit in 1903 Stevens said in part:

"The first thing that I want to do is to remove from the minds of the people that The Toledo Museum of Art is an ultra-conservative association, or an expensive luxury. It is neither one nor the other. It has something to give that all people want and we want them all with us."

One of the last statements Stevens wrote was the inscription which appears in the forecourt of the museum and perhaps best sums up his philosophy and the museum's purpose: "For the benefit of all who seek self-improvement."

Such an ideal and wealth of treasure could not help but excite a person of Molly's interests and potential. Although we both enjoyed the exhibits and musical programs, it was from the museum's School of Design that Molly found the greatest inspiration and help for her art interest. It was here while Blakemore Godwin was the museum director that she spent five years attending classes once a week for two hours. The school was initially opened to school children and when Molly began her studies it had expanded its program for adults. The capable faculty was attracted by the museum's reputation and the excitement of this pioneering project.

In the early forties they commissioned another portrait of Molly by Joseph Floch and bought three of his paintings; Woman in Green, Les Alpilles, Les Baux, Street Scene. *In 1949 they purchased* Sparta Mountain Landscape *by the Greek painter, Ghika. In the fifties a watercolour,* Roosters, *by Pierre Bollaert and* Paris *by Joseph Floch, and in 1965 a figure drawing of S.M. Adler were added.*

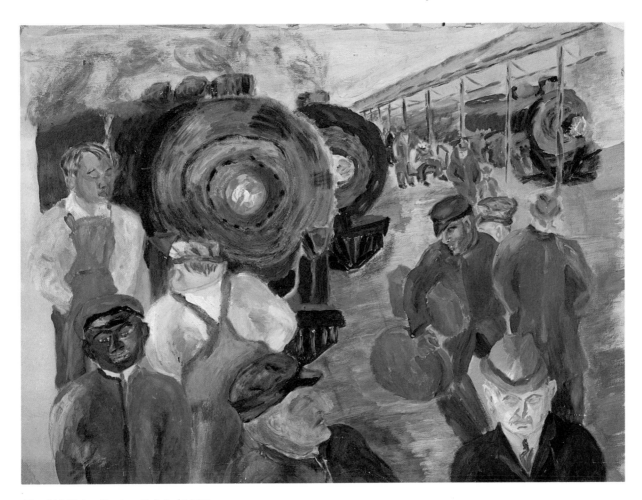

The Old Union Station, Toledo / 1935

According to one of Molly's teachers her studies included the following: basic courses in drawing, design, composition; use of all art tools; work in clay, ceramics, firing; attendance at art demonstrations given by teachers and visiting artists; gallery study, research, reading; lecture courses on the history of art and art appreciation; association with talented artists and the museum staff.

The museum, now under the direction of Otto Wittmann, is still maintaining its reputation as one of the nation's leading cultural centers.

Molly's Interest in Gardening

The circumstance which at first confined us to a small midtown apartment provided Molly with a place for a miniature "garden" on an outdoor balcony. It may have been, once more, the propitious guidance of powers above that saw our road ahead more clearly than we saw it ourselves. If on my first meeting with her I had abandoned my business schedule to linger in Wellington's summer long enough to have visited her family's beautiful country place, perhaps I should have concluded that she was far more aware of her interest in gardening than of her interest in art. Under this impression I might later have sought a little suburban place remote from the Toledo museum as our first residence. Which would have been the wiser beginning or the better road for her, in view of the problems that were to consign us to a childless future, is not even now revealed. So many elements of our course such as this seemed directed by mystical forces beyond my own judgment.

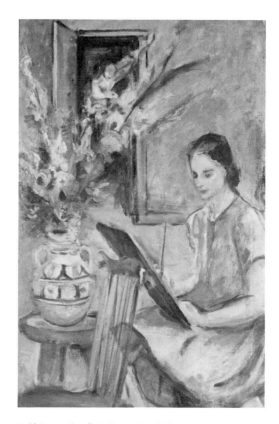

Self Portrait of Artist at Work / ca 1938

*From the books and catalogues left in Molly
Canaday's studio it is possible to see her interest
in American painting grow during
the fifties and sixties–Adler and de Kooning, Hans
Hofmann–and to see evidences of a delight in
the French painters, Dubuffet and de Stael.
The early paintings done in Toledo
between marriage and a return visit to New
Zealand in 1935 show the excitement of her first view
of American art treasures. Like every painter
she chose masters among the dead–and
like many of her contemporaries–
the master was, at first, Cézanne. Tentative
and delicate, the* Urban Landscape *and*
Viaduct in Toledo *suggest
more than an acquaintance with
Cézanne's water colours.*

Landscape

My true enlightenment on Molly's gardening instincts came only after I had remarked admiringly on her having shown so few pangs of homesickness. It was then that she revealed she had sometimes suffered such nostalgia; not only had she felt separation from family and old friends, she also had missed the gardens at home and the Hutt estate. I then realized why her father had once written me: "She is a wizard with flowers. Always they will grow for her." It held far greater significance than I had assumed.

DURING THESE SPRING MONTHS of 1934 a first pregnancy became apparent. This we thought might affect our plans during the year which we hoped might include a home visit for her. However, I was soon aware that she was not permitting her condition to deter her art observations or activities, and in consultations with the doctor we continued to receive encouragement to plan for Molly's departure to New Zealand in the autumn.

Despite the complications, it was disappointing to us both that she suffered a miscarriage although it may have been salutary for her health. Anyway, the mischance ended the prospect that the little son she had been carrying for seven months would have joined the human race as a New Zealand citizen born during her home visit. As it happened, the only result was a postponement of Molly's departure from week to week and finally to early December.

Visit to New Zealand

Meanwhile, as December approached I had a growing belief that any disappointment she might have suffered from the miscarriage would be alleviated by my taking her on a train trip across the western part of the country still unknown to her. It was scheduled with halts at the Grand Canyon, the Petrified Forest, Santa Fe and its adjacent Indian village of Taos, and finally, some days in Los Angeles. During our stop there we naturally visited Hollywood where our first block afoot gave us a glimpse of a parked coupé in which a woman at the wheel had a lion seated placidly beside her. Equally amusing was our departure at 2:00 A.M. from a large party where our hostess stretched forth a hand to us from a recumbent position on a rug in front of her door.

On Molly's sailing date I stood on the San Francisco pier waving her off. Her little steamer seemed fairly to careen on beam ends, speeding her beyond any hope of my trying to snatch her back again.

Such apprehensions as had beset us from the threat of war with possible disruption of trans-Pacific mail and travel subsided temporarily with press reports of China's bowing in seeming impotence to the ultimatum of Japan. Concern was even more illogically lulled by the United States's recognition of Russia and the dispatch of Ambassador Bullitt to Moscow, though I felt that we had thereby condoned the mass brutality and executions reportedly employed in the establishment of the Soviet regime.

She took her talent sufficiently
seriously to give it time, but she
was not possessed by painting. She worked
regularly and was susceptible to a variety of
influences. Her first paintings done in
America, Girl with White Ribbons
and Old Union Station, *show*
an individual eye and strength. One senses
a humane, yet quite caustic, realist.
Here are portraits of recognizable
characters: the alert, vigorous child, the station
crowd where railway porters, commuters,
and workers move freely in and out
of the picture. It is a kind of realism which was one
strand of American painting in the thirties:
in Reginald Marsh's Why Not Use the 'L', 1930,
and Raphael Soyer's Office Girls, 1936.

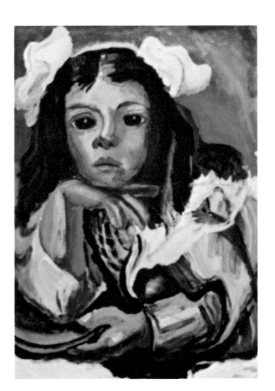

Girl with White Ribbons | 1936

In any event, life for me largely centered on Molly's letters telling of her family's reception welcoming her home for New Zealand's long midsummer Christmas holidays.

With her letters came photographs from her father and sisters and their children, of groups on rocks and beaches along New Zealand's endless, attractive shoreline, of swimming in the pool at the Hutt, or picnicking there in its lovely gardens, and of excursions to North Island forests where a special welcome and official guidance awaited them everywhere in camps established by Molly's brother-in-law, Pat Entrican, then Director of Forestry.

Ages later, as it seemed, I was finally meeting the train from the west coast bringing her back to me and to her life in art. However, it took some time for her to return to serious work, for friends in considerable numbers wished to welcome her back. She could not consider their invitations disruptive, but rather as a palliative to prevalent worry over world conditions and as a support for maintaining a cheerful outlook during this period of great depression.

Study with Israel Abramofsky

As Molly resumed her exploration of art in 1935, starting her third year's attendance at the Museum School, I suspected that she might become aware that she had learned all it could offer her. I was reasonably certain that as a public institution the museum's management would be obliged to limit its instruction to meet the average

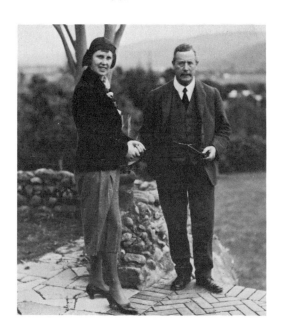

intellectual capacity and to concentrate on repeating elementary courses to attract a seasonal influx of new applicants who were coming in as beginners.

I may therefore only have been paralleling her own unspoken conclusion that she might already have reached a point where museum class attendance should be reduced if not abandoned in favor of an arrangement for the more advanced guidance and encouragement that might be had from working regularly with an experienced professional artist in his studio.

It would have been premature and possibly disruptive for me to have consulted her on this matter before it was determined that an artist of desired qualification was living in or near Toledo, and if so, whether he or she would invite such association. Propitiously, as it happened, one of my earliest

*Perhaps even a little of Ben Shahn is reflected.
It is a vein briefly mined. She must
have had difficulty finding an
individual way in the diversity of modern
painting. Molly Canaday was modest and reserved.
She may well have distrusted her capacity
for discovery and communication.
Whatever the reasons, she worked with a class at the
Toledo Art Museum. The modification
in her style may have owed something also to
their friend, Abramofsky, who
painted her portrait in 1937. After that
date there is a restrained, cooler, more formal
construction. The subjects she
uses are taken from her life—jugs and flowers
and friends. The living room of the
house in Watova Road grows familiar. Friends
sit in armchairs or look out of windows,
relatives play the violin or her
treasured pianoforte, her mother-in-law
writes letters, her husband
works at a table in the apartment.
These domestic paintings are tentative or tenderly
awkward, but they are lifted by their
honesty. In a quiet way they document a modestly
comfortable, conventional American life.
It would be a pity to dismiss
them with the label "woman's paintings"
(so they are, and why not?) without remembering
how few of us really know
ourselves or even document our lives truthfully.*

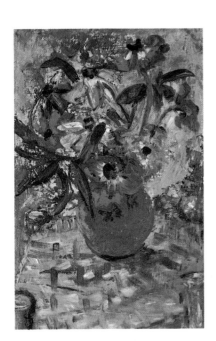

Anemones in Jug / 1939

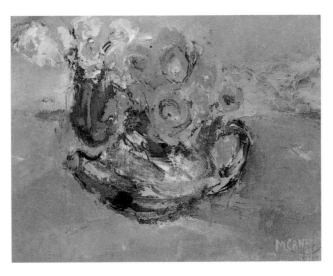

Roses in Teapot / 1934

inquiries put me in touch with a Judge Cohn, highly respected and popular in local cultural circles. He informed me at once that Israel Abramofsky was considered in art circles the leading painter of the area, and that he would not only welcome such an association with Molly but that she would undoubtedly find him most congenial. After meeting the artist in his midtown studio I was confident that such feeling would be mutual. Abramofsky said that he would gladly accept an arrangement to have her work alongside him in his studio one day a week. He planned to convey to her, by discussing his own work and hers, something of his several years of absorption of painting techniques and their successful practice in Europe and America.

Born in Kiev, in 1884, he had fled the Russian persecution of Jews and in his late teens walked to Paris hoping to study art there. In 1909, seeking earnings that would better support his art pursuits, he found work in a Toledo motor factory and painted when time permitted. Through a friendship formed with Judge Cohn he received a commission to paint a portrait of Brand Whitlock which led to a further commission by Toledo's Collingwood Temple to do a portrait of Rabbi Rudolf Coffee.

With generous fees for these accomplishments added to his savings he promptly returned to Paris and further art study. However, he mainly hoped to benefit from an extended professional intimacy with artists of outstanding talent and from learning more about their studio methods and works.

In due time his experience extended to a period of study at the Royal Academy in London where some of his paintings were exhibited.

Returning to America he became a citizen of the United States where he was soon engaged to paint a World War I portrait of Secretary of War Newton D. Baker. This and other distinctions led to purchase of some of his other works, including *Fountain of the Luxembourg Gardens,* by the Toledo Museum of Art. Portrait fees and sales enabled him to return to Paris where he secured regular acceptance of his work in the Salon des Artistes and in 1928 he received an honorable mention in a major exhibit which placed his name on the international roster of the "known." One of his paintings, *Village in Brittany,* attracted particular attention in the French Salon's 1931 show, and was purchased by Judge Cohn as a gift to the Toledo Museum of Art.

His reputation overseas was established primarily from the purchases by the French government for the Luxembourg Museum in Paris of his *Winter Scene on Mont Blanc* and by the Museum of Jaffe in Palestine of his *A Street Scene in Paris.* In New York the Brooklyn Museum added *The Fisherman* to its collection and in 1936, at my request, he made a first portrait of Molly which became the feature representation of his work in the Toledo Museum's 24th Annual Summer Exhibition of Contemporary Painting.

I can remember how Molly used to come home from his studio quoting some phrase which had been the subject of his emphasis, such as, "Dak—light, dak—light," and often again "Dak—light, dak—light" was

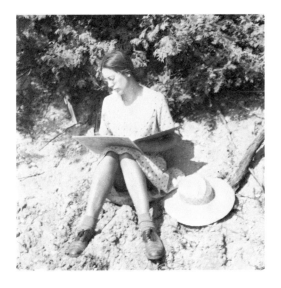

her entire report of the day. It meant, of course, his concern over a continuing aspect of Molly's work that would benefit from more contrast, by sustained attention to wider differentiation in values and colors, and that he felt she would thereby more nearly attain greater success in arriving at the effect she was obviously seeking.

Apart from any such specific instruction, Molly's techniques, as well as the range of subjects she attempted, were broadened by her observations of his work and his occasional comments on his methods.

During these sessions in his studio Molly was stimulated by observing his work and received encouragement from his comment and criticism which contributed to her self-confidence.

He spoke a ready English, but his inadequate vocabulary sometimes frustrated him in his effort to discuss one or another of the aspects of painting to which he felt it important that Molly give regular and more concentrated attention.

During these years Molly and I formed a lasting friendship with this courageous emigré who, to the end of his life in 1975, devoted himself wholly and intensively to a career in painting.

FAMILY LETTERS written to Molly at Christmastime in 1935 still came by plodding ocean steamer and arrived late in January, 1936. Included was one from her father in which he announced his intention to fly to the United States for a visit during the year. Molly's mother had died before our marriage. With his visit in prospect, I began at once to arrange for his participation with us in the forthcoming celebration of the Harvard University Terecentenary. Having been secretary of the Harvard Club of Toledo and being then its president, I obtained an invitation permitting my father-in-law to accompany us to the tercentenary events.

Considering the impending demands of her father's visit and attendant events upon Molly's time, her production of any art work worthy of note could have been considered extraordinary in the summer of 1936.

However, preoccupation with painting, concerts, and theater, supplemented by exchange of hospitality with friends, filled the summer of 1936 until we met "Dear Old Sir" at the airport in New York on his August arrival from London. After a day's tour of the city we set forth in our car to introduce him to Washington and Philadelphia where our tours included opportunity for Molly to see some of the current art shows and review acquaintance with great permanent collections, particularly those of the Philadelphia Museum of Art and the National Art Gallery in Washington.

In due course we drove directly to Cambridge, Massachusetts, where we enjoyed various functions preliminary to the day of

the main Harvard Tercentenary program and made tours of historic Boston and vicinity. In Cambridge this included the University's Fogg Museum and the Germanic Museum, the latter showing at the moment a visiting collection of German paintings of the fifteenth and sixteenth centuries. In addition Molly saw the superb collection of the Boston Museum of Fine Arts and masterpieces that Isabella Gardner had collected years earlier and housed under her strict direction in the extensive domestic background of her Boston palace which by that time had become a public heritage.

In addition to concerts by distinguished performers, class reunion gatherings and luncheons, we attended an afternoon commemorative assemblage in one of the older quadrangles where an ode was read at the unveiling of a bust of the late Dean Briggs, long an eminent and delightful figure in office during my undergraduate years and beyond. After watching a torchlight parade of undergraduates that evening, we got a much needed long night's rest and awoke next morning with the chief formal ceremony of the celebration in prospect. This, attended by many notables including President Franklin D. Roosevelt, gave us all, and Dear Old Sir in particular, full appreciation of the privilege accorded us in our admission there to well-placed seats. The facilities were inadequate to accommodate the countless guests from all over the world. One, incidentally, the president of New Zealand's noted Victoria University, came from Wellington.

The following day, after visiting Longfellow House and other famous Cambridge residences, we drove out to tour historic

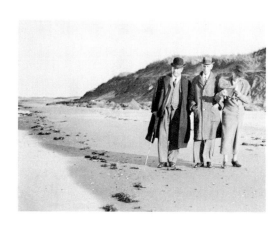

Lexington and Concord, then proceeded through New Hampshire and Maine and crossed into Canada's Quebec. At the border I parted from Molly and her father to drive back to Toledo, leaving them to proceed as they had wished on their pilgrimage to the Prince Edward Island background of Dear Old Sir's forebears of two generations earlier.

Among many reports of their genealogical mission Molly told us particularly of their having been invited to tea by a Mrs. C.H. Robinson of Christiansted who, in her ninety-fifth year, was the only person still alive there who had personally known the group which departed for New Zealand on their chartered ship some seventy years before.

"Tell me, child," she asked, referring to Molly's grandfather as the adventuring boy of twenty, "and did Willie keep his figure and lovely curly hair?"

After locating the ancestral home where the forebears of New Zealand Morpeths lived before their migration, Molly and her father returned to Toledo, stopping in New

Molly, Ward and Mother Canaday . . . 1937

York City long enough for a classmate of mine to give them a personally conducted tour through two world famous financial strongholds, the offices of J.P. Morgan and the New York Stock Exchange.

Ensuing social events resumed in our own home and the invitations of friends kept Molly's father busy until early November, culminating in a Thanksgiving Day dinner with my brother Ward, his wife Mariam, and their daughter Doreen, and other members of my family. Dear Old Sir's delight in his remembrance of this visit was expressed in his Christmas letter of a year later:

My darling daughter,
Here we are again within sight of Christmas, but not with the shining snow 'bright and crisp and even' as it was last year. Never shall I forget my introduction to real snow in your darling company; what a fascination!

Move to New York Deferred

During the week of Molly's birthday in February, 1938, she received not only her father's belated gift of two volumes of a thin-paper edition of Kipling's works, but also from a friend in New York several catalogs of current art shows in commercial galleries. One invited a view of some contemporary Hungarian paintings, another from Karl Nierendorf's Gallery showed offerings by such conspicuous modern painters as Karl Hofer, urban realist, Lyonel Feininger, whose early contact with cubism gave him strictness in all his color renditions, Paul Klee, who came to feel that the creative process took place mainly in the subconscious, and the earlier innovator Vassily Kandinsky, pioneer experimentalist with retreat from objects in abstracted paintings that gave freedom for his glowing colors to seethe and explode and collide.

Accompanying this latter catalog was a letter mentioning that in the gallery's permanent collection were works by Picasso, each aspect of whose diversified work built Molly's concept of him as the most versatile artist of our age in mastery of painting; Leger, each of whose color lines asserted its own individual quality; and Miro, whose roots in cubism were freed by contact with surrealism which contributed delightful fantasy to his later expression.

Each time such catalogs came it was evident from her expression and comment that Molly harbored a considerable hope that some turn of events or fortune would enable us one day to live in New York. In time I came to consider such a move as justifiable in view of my own desire to with-

Fifth Wedding Anniversary . . . 1937

draw from the field of business writing and attempt a career of writing fiction.

However, for the moment, Molly, considerate of my efforts to regain a position of some financial independence, contented herself and sometimes consoled me with the thought that the art shows which came to the Toledo Museum of Art and the superior musical concerts were perhaps as much cultural fare as she was prepared to absorb. Further, the analytical notes in the printed programs commenting on works performed by the principal orchestral groups, offered valuable supplements to the lectures on music appreciation which we had attended.

IN THE FAR EAST in 1939 not only had the Japanese moved deeply into China but they had progressed toward the South China Sea and as they spread into Southeast Asia our personal hopes for future New Zealand visits were threatened. Worse still was concern that there might eventually be a Japanese attempt to invade Molly's homeland, and this apprehension was reflected in family letters. However, we and our friends in Toledo had long cultivated the habit of dispelling such gloomy forebodings. Although the atmosphere during the first half of 1939 was pervaded with disturbing speculations about international developments, Molly continued to paint and draw except as her art activities were diverted by our move from the Plaza Hotel apartment to a duplex on Robinwood Avenue.

The change of residence soon had a noticeable effect on her work. The prospects of a real garden around the house led her into some late-winter preparations for its cultivation and thus intermittently to increased outdoor sketching. When spring came it reduced further Molly's now diminishing dependence on the classes of the museum School of Design for art guidance and emphasized the beginning of a greater sense of self-direction in her creative activities.

Recommendations made from some unknown quarter led to my appointment to fill a Toledo vacancy in the office of consular agent for France. This became a source of interest to Molly, as well as myself, when it brought into our life acquaintance with French visitors of distinction—amongst them Mademoiselle Eve Curie, noted not only in her own right politically but also as the daughter of the scientists who discovered radium.

Painting—Music and Ballet

Molly was aware of a number of experiments which sought to demonstrate a basic relationship between music and painting. Our numerous discussions of these experiments revealed Molly's skepticism toward such demonstrations and their value for either art. She made clear, however, that this was not to deny that the rendition of stirring music heard by a painter might occasionally provide an avenue of release to a talent struggling for more complete freedom in the other medium.

More directly influential, made evident at every ballet performance we attended, was the opportunity provided to see the human body in beauty of movement, creating compositions of aesthetic excellence, emotional effectiveness, and human significance. It delighted her to discover gradually the immense range of versatility of this medium in expressing every emotional condition of human life even to a delicate conveyance of humor, as demonstrated in such varying degrees by the Trudi Schoop Comic Ballet Troupe.

We first saw this group in New York as part of Molly's February, 1938, birthday week celebrations. Thereafter in her figure paintings there were always a few elements of humor immediately or eventually discernible and traceable to this influence. Year after year, both in Toledo and New York, we sought out performances of the most noted traditional ballet troupes to study their skillful portrayal of movement and posture which expressed the whole range of human emotions and relationships.

WHATEVER ILLUSIONS or hopes for peace America and the rest of the world may have had were shattered when newscasts reported Nazi panzer units had invaded Belgium on September 3, 1939, and World War II had at last begun. Although two years were to pass before the United States would be drawn directly into the conflict, the very threat of such an upheaval would shortly affect both of us, Molly especially, with the arrival of a well-known artist from France.

Of Molly's work in this period I had a layman's sense of improvement in both drawing and painting, particularly in specific aspects of technique and approach which became characteristic of her creativity in later years. Her developing technique was enabling her to express her ever-deepening sense of color more effectively. She was moving beyond realistic detail in her sketching and, through minor adjustments of line, contributing wholly unforeseen significance to a model's pose and far greater force to her work.

I recall in a study of a head and torso, her first experimental linear use of color with nuances of shading that conveyed underlying physical form and structure. I can recall, too, a maturing instinct to convert such commonplaces as the brick and mortar of a city landscape into a harmonious composition of appealing tone and color, an early expression of the unfailing taste that characterized all of her future work. In her landscapes an impressive sense of space organization was emerging, leading those of us who knew her well to speculate that its underlying source might have been the long hours spent earlier in planning the Hutt Valley garden with her mother. She was reaching and she was learning.

Cape Cod
1939

3

The Later Toledo Years

NINETEEN-FORTY was the year we moved still further out into the suburbs of Toledo to a house on Watova Road, a move which precipitated Molly's gradual detachment from museum classes and studio sessions with Abramofsky. Now we had a house with a larger garden nicely situated on the edge of a rural wooded ravine. Within, the spaciousness of the rooms invited larger paintings of interiors, plus the use of private models for figure sketching or still life subjects, especially garden flowers. Outdoors there was a far wider range of subjects for practice in drawing and portable easel painting. Equally important was the opportunity for more extensive gardening which I have previously observed was so vital to Molly's happiness.

The year 1940 was also remembered for Molly's fearsome abdominal operation for a tumor which had extended to an area which finally doomed our hopes of having children. It was good that business pressures subsided temporarily for I needed time to give her care and relieve her of burdens at home. For the first time we had a maid in the house and Molly claimed I kept the poor girl cowering in her room until Molly and I had breakfast and I had left for the office.

How Molly benefited from every opportunity to draw and paint is illustrated by the fact that the youthful red-headed maid was used as a model—perhaps spending more time posing for Molly than helping with housework.

As Molly gradually regained her strength she became increasingly active and, following a suggestion made by our friends, Erica and Hans Tietze, Molly formed a group which promoted interest in adding contemporary works to the Toledo Museum's permanent collection.

Erica and Hans Tietze

By the 1930s Viennese-born Hans Tietze had become a recognized authority on the Venetian school of painting and was married to Erica Conrat who had been a well-known Austrian fiction writer. After their marriage she too became an art historian and the couple, who resided in Vienna, collaborated on several books. Hans was on a lecture tour in Italy, accompanied by Erica, when Hitler suddenly occupied Austria and the Nazis took over the Tietzes' home, making it impossible for them to return. Worse still, they had become exiles without a country.

By good fortune, about the time Hans concluded his Italian lecture tour the Toledo Museum of Art, which had been given money to establish a grant to provide for a lecturer from overseas, offered him the post for the forthcoming year. Although the Tietzes spoke English well and knew

*Molly and garden
at Watova Road*

French, neither had previously been to the United States, and I therefore surmised he might welcome some editorial assistance with respect to the current use of idioms and proper names. He graciously accepted my offer of help and we thereafter became close friends.

Erica was soon teaching a class in art history at the museum School of Design which Molly attended. During the ensuing year Molly broadened her background and profited considerably from this association with Erica.

At the conclusion of Hans' assignment the Tietzes left Toledo for New York City and later reported that they had taken an apartment in Manhattan and that a working place had been offered them by the Frick Art Reference Library.

"Now that you know we are settled," Hans wrote, "we hope you will not mislay our address, but sometime make use of it."

While we did see Erica and Hans later that year in New York, their invitation was to have its main effect years later when continuing friendship with these talented and charming exiles from Vienna was to influence our eventual move to New York.

There we were to share occasionally a meeting with the distinguished creative people of their Viennese past and their American present. There Molly was to meet the painter Kokoshka, the family of the playwright Beer-Hoffman, the Metropolitan Museum's curator of ancient musical instruments; also, of the Tietzes' family, a son distinguished in international sociological work, and another son from Turkey, a specialist in Arabic cultures of the Near East.

During the winter of 1941 when we were dining with the Tietzes (who were now in New York City) Hans showed me some photographs of figure paintings by a Joseph Floch, and I said:
"If he ever comes to the United States I should like to ask him to paint a portrait of Molly."

September brought an unexpected reverberation from Hitler's war and homicidal policies toward the Jews which was destined to turn our lives into totally new channels. A letter of September 24, 1941, from Hans Tietze to Molly, written from New York, announced the fulfillment of my hope that Joseph Floch would arrive in America. By what narrow ways he had accomplished this escape with his wife Mimi and two daughters from the spreading threat of Hitler's genocidal tyranny was hinted in this letter which said in part, "We saw Joseph Floch who came over on that infamous Spanish steamer that, although having accommodations for a dozen people, brought something like 1,500 Jewish refugees. The Flochs, as supposedly most of the others too, are of course terribly worn out and are now at the seashore to recover." This brought into question at the same time whether or not Joseph's condition would permit him soon to undertake such a commission as I had suggested.

By October 31 Hans was writing again of having given two further letters of mine to Floch and of his hope that our meeting a few days hence would work out all right.

I can hardly express how deeply we appreciate your friendliness to accept a complete stranger in the intimacy of your household and to aid him in his first steps in this country, which offers some difficulties to the beginner. It will be especially helpful to Floch, who is a great worrier, partly by natural inclination, partly because of the sad experiences through which he went these last years. If you find him less cheerful than we should like, believe me, he has an excellent and very reliable character.

In a following letter Hans confirmed to me that Joseph would soon be sufficiently well to come to Toledo and we were to learn promptly that this talented and experienced European painter was to figure importantly in our life. We were also eventually to realize that his visit with us in Toledo was to have a significance far beyond my original concept of his merely "doing a portrait of Molly," for he was to become at once a great friend and one of her most authoritative early critics and some years later the chief guide in the development of the skills that released her talent.

Visit of Joseph Floch

Although I had some concern about the wisdom of Molly's undergoing any strain that might be involved in having a guest in the house for a considerable period and posing for a portrait, we decided to invite Joseph Floch to Toledo. It was evidently vital that he have the encouragement which Hans felt we might offer him.

A letter from the painter, in French, told us when to expect him.

Dear Mr. Canaday,
. . . I am already anticipating the pleasure I shall have in meeting you . . .
Yes, I do speak a little English, a very little, and the rest I shall do with gestures! So, I hope that **Mrs. Canaday, with the aid of some French words,** *will understand me.*

J. Floch

So came about this very pleasant encounter with a charming and stimulating guest who dominated our life at home for a week.

The portrait progressed and came forth as a head and torso portrait of Molly representing all her beauty of spirit which had evidently impressed Joseph within those first few days' acquaintance. I had used a wrong terminology in commissioning a "portrait" and did not get a full-length figure representation like those of which the Tietzes had shown me photographs, but I was pleased and accepted the first canvas offered.

During his week in the house with us Joseph saw Molly's current work and gave her valuable criticism. I began to think in terms of her having some further guidance from him when he should be established in a studio in New York. First, however, appreciating his immediate needs, we secured for him a showing of a few of his "portraits, figure studies and landscapes" in the school lobby of the Toledo Museum of Art. This attracted sufficient notice on the part of the museum directorate that one *(Young Girl Seated)* was accepted for its permanent collection, a gift of the Art Additions Group which Molly had organized.

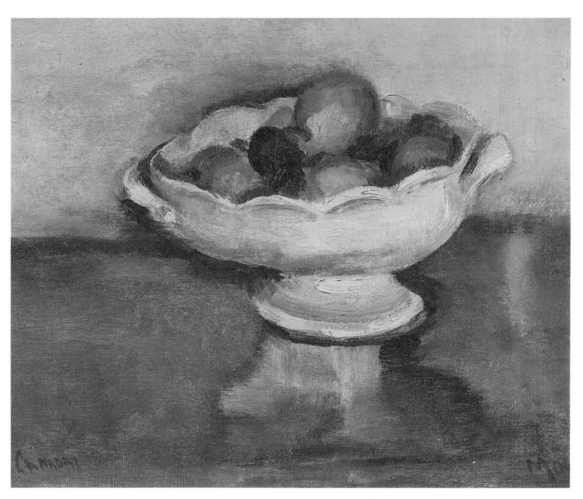

Fruit in Gray Bowl / 1942

*Molly Canaday treats her sitters in ways which
reflect the thoughtful restraint of that
person you see in her self-portrait. These people turn
their backs, look out of windows, per-
haps to distances they cannot cross? They are
often a little sad. The painter has an
eye for the emotional significance
of stance, reading the way people sit or stand, and
knows how a back view can
show as much character as a face.*

Watova Living Room / 1942

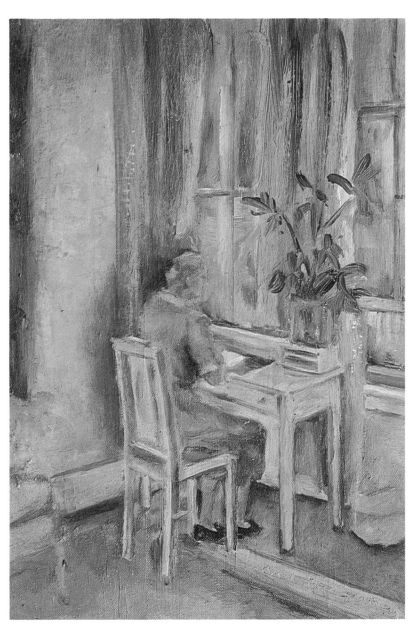

Mother Canaday at Molly's Desk / 1943

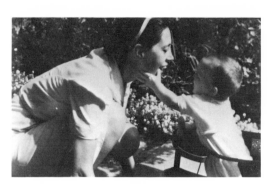

Molly and small friend . . . Watova Road

To assist Joseph more adequately in his difficult start in America, Molly and I conceived the idea of offering him a one-man show in our own house and inviting friends and acquaintances known for their art collecting interest to come to the showing. With Joseph's prompt cooperation we set the date for early December and stripped our living room walls to give all possible space to his available work brought from France. We made it the occasion also for a first exhibit of his new portrait of Molly.

The local papers gave the event excellent notices, one on the society page announcing us as

hosts at a tea 4 to 7 P.M. for members of the Art Additions Group in honor of their distinguished guest, Joseph Floch, French artist . . . Mr. Floch is a personal friend of Dr. and Mrs. Hans Tietze, former visiting authorities at the Museum. Mrs. Canaday, as president of the Art Additions Group, has invited its members to attend a private afternoon showing of Mr. Floch's portraits and other paintings.

By previous announcement Mr. Floch had already been introduced to the Toledo public with a brief biographical sketch, identifying him as having been born in Vienna in 1896 and as having received recognition as a painter of note before going to Paris in 1926. It mentioned his experience of several years in painting and teaching and the wide exhibition that had been accorded his works in European galleries and museums, including the Albertina of Vienna, as well as the inclusion of one of his works in the French exhibit at the New York World's Fair of 1939.

On the date set for this reception the *Toledo Sunday Times* presented a feature article about him along with his photograph beside the work, *Young Girl Seated,* chosen for the museum's permanent collection.

The day of our reception was one that was to become historic. Guests had come in numbers to our house in mid-afternoon of that Sunday, December 7, and were viewing his paintings with apparent appreciation, when the whole promising introduction was violently disrupted by a radio report of an attack by the Japanese on Pearl Harbor!

I can still see Joseph crossing the living room toward me, hands clapped to his head as he said with quiet despair, "This *would* happen to me."

However, after guests had listened to some of the further excited reports pouring in over our radio, the excitement subsided in favor of some attention to tea and a further viewing of Joseph's paintings, with results more immediate and substantial than might have been expected. The day ended with one of his paintings of a French landscape sold and a portrait of the wife of one of our friends commissioned by her husband.

At Floch's then modest price demands the total proceeds of the day were considerably less than a thousand dollars, but in his condition at that time this "fortune" gave him a light of encouragement that shone far down the road for him and lighted a new prospect in life for Molly and for me.

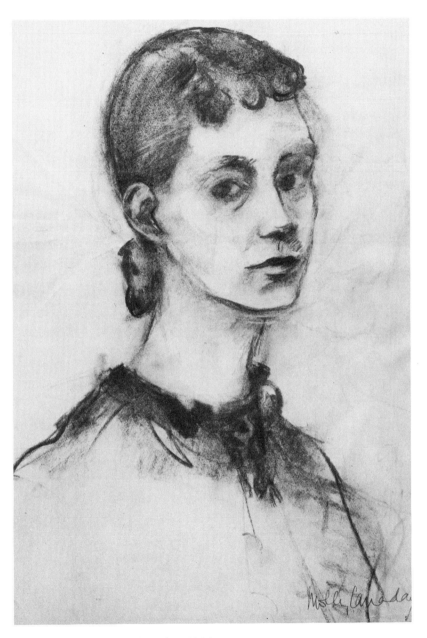

Molly with Bangs-Self Portrait / ca 1944

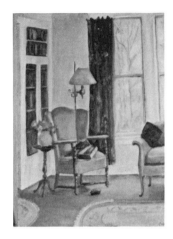

Interior, Watova Road
Yellow Armchair / 1942-43

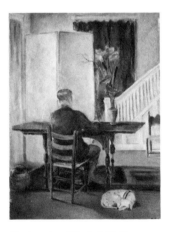

Husband at Work / 1943

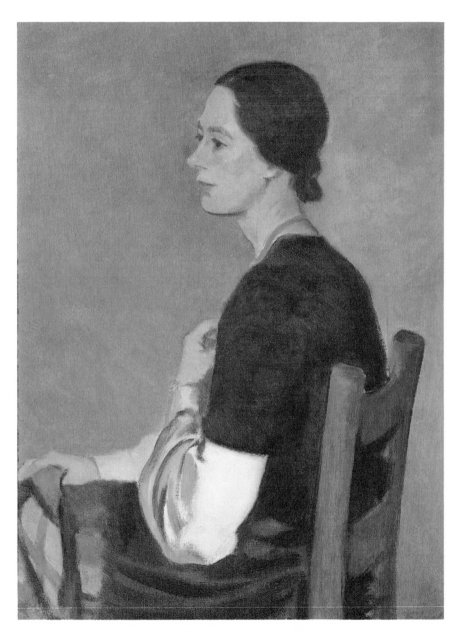

Joseph Floch's first portrait of Molly Canaday painted in 1941

Tea on the Terrace / 1942

Studio Corner / 1944

Country Lane / 1942

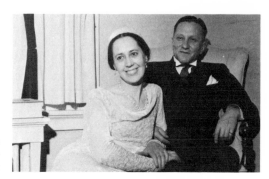

*Molly in wedding gown with
husband in background at Ashley's
25th Anniversary party*

Floch's first letter in English offered help to Molly:

Dear Molly,
Thank you for your letter and $100. I am still in Cambridge, so my answer comes a little late.
If you are painting again a canvas it is necessary to make it sure [secure] by tasting with the finger whether the paint is still sticky. The surface has to be absolutely free of any sign of adhesion.
I hope to see soon your work.
This is my first letter in English. Beg your pardon for the faults. I think this is my whole vocabulary!
With my affection for you and Frank,
Yrs.
 Joseph

This letter, written while he was visiting another interested patron in Cambridge, Massachusetts, had a dominating quiet note that was to set for Molly the basic pattern of another important period of advance in her life's emerging symphony, for the association with Joseph Floch was to provide technical guidance and encouragement not only in 1942 but over a number of years to come.

The check mentioned in this letter was the first money earned by Floch in America. His letter represented a sense of congeniality which was mutual and spontaneous from his first days with us. His instant recognition of Molly as a fellow painter was revealed in the intensity with which he plunged at once into a continuation of the counsel he had been prompted to offer her out of his longer experience when he had seen some of her first early paintings on our walls in the Watova house.

There he had evidently observed that Molly's spirit of economy had led her to re-use certain canvases with which she had not been content, scraping off a first composition in favor of a new concept. From this observation had come his admonition for tasting [testing] with the finger!

Underlying his brief, "I hope to see soon your work," Molly was to learn, was a deeper interest in her progress in painting than his meager English had permitted him to express. He encouraged her repeatedly through succeeding years to send canvases to him in New York for specific criticism and, as this opportunity for guidance in technique from Joseph's years of experience was accepted at intervals, it led to Molly's going a few times in the mid-1940s for a week's study in his studio in New York. Eventually the worth of such tutelage became one of the decisive elements in our decision in 1947 to move our residence to New York.

T HE SHOCK of Pearl Harbor which projected a startled United States into World War II had brought to our personal life more positive inspiration toward accomplishment. In spite of the global conflict a too little appreciated mid-western city continued to press upon us enticing social and cultural activities.

By no means unmindful of the war effort which was the principal topic of conversation, I set about finding a teacher with whom I could study Japanese so that, should the war last for some years, I might be of aid to the government in some capacity. Meanwhile Molly gave lectures at the

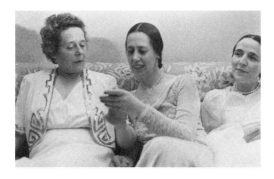

Alida Ashley, Molly, and Emma Endres Kountz at the same gala event

YMCA to reassure mothers of men dispatched for service in New Zealand that there were elements of civilization in that distant country, a land which was then only slightly familiar to most Americans. As Molly regained her strength it was the art exhibits which chiefly fed her spirit; later I found that she tucked away many bits of evidence of this consuming interest, such as a catalog page on the life of Saint Cecilia, taken from a painting in the Uffizi Gallery, Florence, by a contemporary of Giotto.

Although most of the art displays Molly saw in the museum were works of famous painters, the majority showing "representational" art, she was becoming increasingly aware of the newer group of artists who were said to belong to the "non-representational" school.

In a letter in French from Joseph Floch dated February 2, 1942, he wrote to Molly,

I see clearly your ravishing garden with its small bits of sculpture and the flowers. With the help of le bon Dieu you have created a living picture. What a pleasure! But I look forward to seeing your paintings, and I am sure you can profit from reading my critiques. So, dear Molly, always keep sending what you do and I shall give you my ideas about them insofar as concerns your progress. In your earlier ones I was concerned with the drawing and technique; now I want to see you pushing forward with color.

In spite of dour reports from most of the world and a personal concern about the security of those in New Zealand, there were many happy times in our home, with Molly, her strength returning, working as-

siduously again. She prepared paintings making use of Joseph's latest suggestions and looking forward to showing him work for further criticism.

However, she did not always go in to see exhibits offered by the Toledo Museum in the early months of 1942, which included "Art of Korea, Manchuria, Mongolia and Thibet," "Ohio Watercolors," "Contemporary Art of Chile," and the "24th Annual Exhibition of the Toledo Federation of Art Societies." She did go once during the summer to scan briefly the annual show of "Contemporary American Paintings" and the Toledo Walbridge family's "Collection of Prints."

In the autumn came "Art of Australia," "The 20th Annual of International Watercolors," "Contemporary British Art," and "Life in Ancient Egypt." Her comments upon the Australian show were published with a photograph showing her examining one of the canvases.

Art: Representational or Non-Representational

In 1943 Molly saw a few early exhibits of the new season in New York which included some works of "meticulously detailed naturalism," assembled into interesting patterns of discarded objects. Critic Edward Alden Jewell used them as a platform to discuss the distinction to be drawn between "representational" and "non-representational" painting. Molly called to my attention that in the previous week he had sought to clarify definitions of such

terms as "naturalism," "realism," and "reality," adding "In art of our time we are repeatedly asked to accept as 'reality' much that happens to bear little or no relationship to 'nature,' the 'real world,' or 'real life.' "

It was suggested that truth of any kind is as much a reality as the "real" all about us in the world, which artists may or may not elect to report in art realistically.

Although 'truth' is an abstraction, Jewell wrote, *it has a sly way of coinciding with the concrete. There can be no doubt, I think, that the general public is prone to accept art that is completely or relatively 'naturalistic,' and to reject—or, at least, to be extremely wary of—art that completely, or in large measure, departs from such procedure.*

This would seem in the perspective of forty years to be about as futile an attempt to disentangle art definitions as had been otherwise achieved in the past four decades of art analysis, discussion, and definition, even though this competent critic made this effort in the midst of political misdirection and the world catastrophe of the forties.

However, to quote Mr. Jewell has pertinence because his words represent quite fairly, I would say, the controversial atmosphere in which Molly set out to find her personal way into valid artistic expression. I feel confident that it was through many uncertainties of direction and a wide range of experimentation and pondering that her persistence carried her to achievement. She never deserted beauty and taste as she persisted toward meaningful self-expression.

It may be helpful, therefore, in characterizing the combined political and artistic chaos that accompanied her early searching, to cite further from Mr. Jewell. The question that Jewell said may well be asked at this point is:

In adopting such an attitude (or rejection or wariness), do we not run the risk of narrowing our gamut of appreciation, which might conceivably be broadened were we to make a genuine and, if necessary, prolonged effort to understand certain types of artistic expression that are now rejected on insufficient critical grounds?
On the part of those who insist that art be representational, there is, I'm afraid, a tendency to assume that all reasonably fortunate people see alike, and that art that is non-representational, failing to deal with natural objects clearly recognizable as such, is produced by artists who deliberately shut their eyes, or else who are not physically equipped to see, as do the more fortunate, what is 'really' there.

He cited the conclusion of William M. Ivins, curator of prints at the Metropolitan Museum of Art in New York, who had said,

In spite of identity of subject, the prints do not look alike and are in many respects contradictory and irreconcilable. Each bears the distinct marks of its time and of the nationality of its maker. Any object which you and I see with our own eyes is different to the eyes of everyone who sees it.
These excerpts of Mr. Ivin's thesis may serve to hint at some of the enormous implications that should cause those who talk too glibly about art's relationship to nature to sit down at once and do a lot of serious thinking before they seal forever in a vacuum their conceptions of 'reality.' In the end you may still prefer one form of reality to another, but you will then do so with the satisfaction that

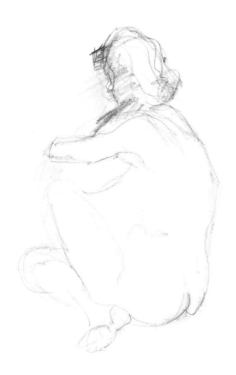

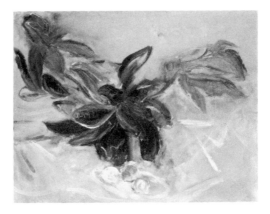

Leaves and Fruit / 1943-44

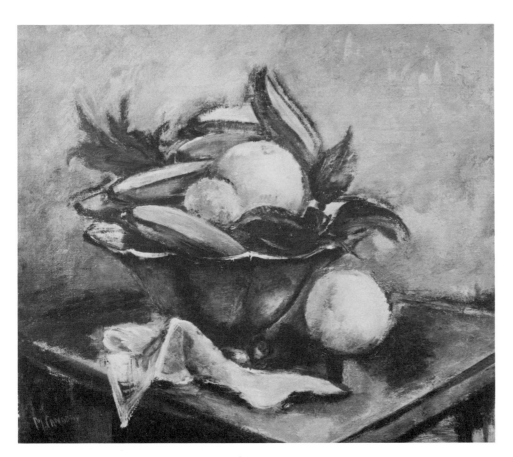

Vigorous Bananas / 1943

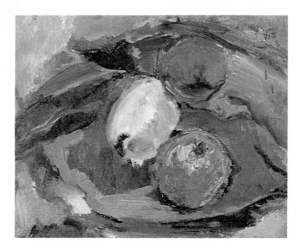

Blue Bowl and Fruit (detail) / 1943

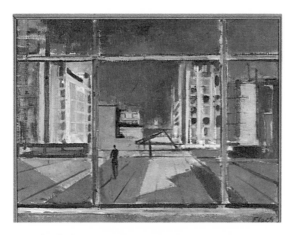

*Joseph Floch's "Street Scene" painted in 1943
and purchased by the Canadays.*

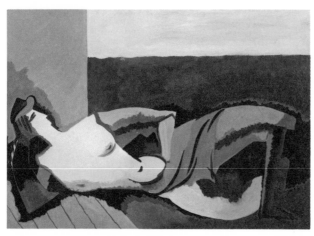

*Lurcat's "Reclining Dancer"
purchased by the Canadays in the 1930s*

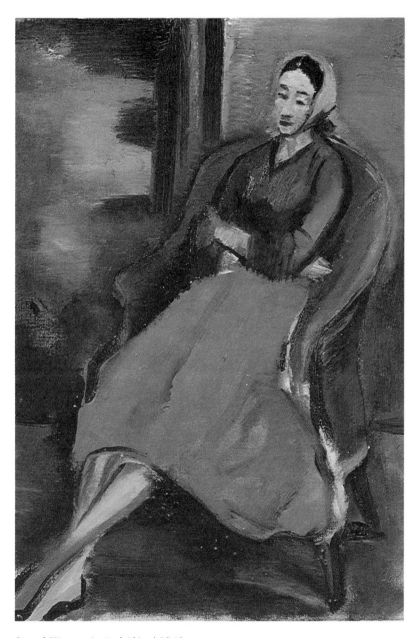

Seated Woman in Red Skirt / 1948

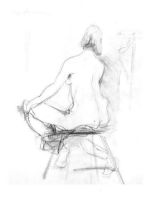

can be experienced alone by those who have carefully pondered these matters and who know the reasoned why behind such preference.

Molly found Jewell supporting much that she herself had concluded, especially when he said,

I am not striving to disparage the representational in art, nor to exalt to the skies the nonrepresentational. I am merely trying to make it clear that there is no standard or uniform process of 'seeing,' and that the true artist paints according to his own vision whether this vision be concerned with outward fact, with inward fact, or with a creative blending of both.

As the artist strives to express what holds significance for him, so should the spectator strive to evaluate on a basis of understanding, not prejudice. It isn't enough to be satisfied with the accustomed, if we are to keep abreast of the onsurging culture of our time . . .

This article of the early 1940s was found stowed away for future reference and it may have aided Molly enormously to avoid some of the devastating powers of the "realistic" world of illness, anxiety, bloodshed, and destruction. Perhaps even more clarifying to Molly was the comment of Edward F. Rothschild from his book, *The Meaning of Unintelligibility in Modern Art:*

In art we are not looking for something we already know; we are looking for a new experience whose value and quality are unknown to us. In such a case, to permit unrecognizability to be a barrier is to condemn ourselves to a life of monotony, without the thrills of discovery, insight, and 'conversion.'

Critic Howard Devree was calling attention to works of pure abstraction by Piet Mondrian in a collection being shown in Sidney Janis's Gallery which Molly regularly visited. The critic also commented on an exhibition in the ACA Gallery which included canvases by the brothers Raphael and Moses Sawyer. They later achieved considerable fame in New York and since Raphael Sawyer's studio was adjacent to Joseph Floch's, Molly knew them personally. Some canvases of Joseph Stella whose work Molly later admired greatly were in this same show.

In the foreword to the catalog of this show, Herman Baron, then director, said that ACA was being receptive to new ideas and was encouraging all schools of art, sponsoring especially art that was concerned with social themes.

IN 1943 Molly received a letter from Hans Tietze praising her article in the Toledo *Museum News* concerning the two acquisitions given the museum by her Art Additions group. He wrote in part:

A few days ago we had the issue of the Museum News *with your excellent article on the two acquisitions; certainly you are a born newspaper woman! Nobody could have made a better job . . .*
In my opinion you should certainly continue the activitiy of the Group in spite of all current difficulties, which, on the contrary, are another reason not to stop.
When you are in New York this spring, as I hear from Joseph you plan to be, you should try to find something American to demonstrate that my influence prevailing in the acquisition of works of two Austrian-born artists is now over and that the Group has now entirely come of age . . .

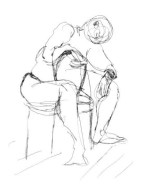

This struggle to make significant the line of a
figure's silhouette can be seen in the progression of
her drawing. Her drawings also show
that she was aware—from the distance of
Ohio—of some of the ideas which were shaking the
painters in New York. Drawing for these
anti-Renaissance artists was used to
express something other than seeing or thought.

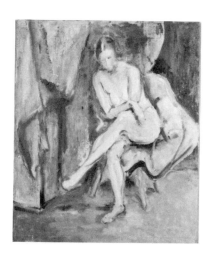

Seated Nude / 1942

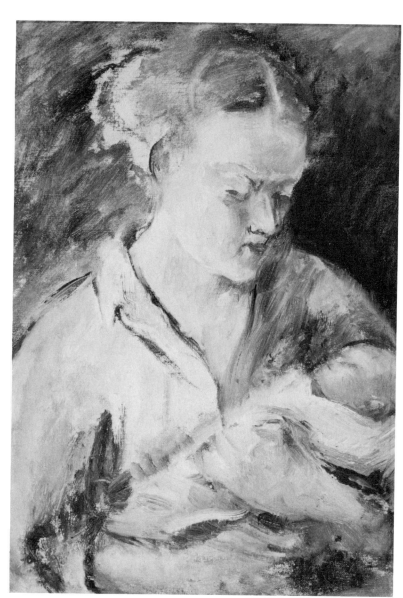

Alexis and Baby Andrew / 1947

He drew attention to the distinguished patronage accorded in England to Georg Ehrlich, sculptor of the head of Erica (Conrat-Tietze) that Molly's Art Additions Group had contributed to the Toledo Museum's permanent collection. "I am sure you will be pleased to hear that the Tate Gallery in London has just acquired one of Ehrlich's *Italian Fisherboys* and that Sir Kenneth Clark, the director of the National Gallery in London, and keeper of the King's pictures, ordered a bust of his eldest son from Ehrlich and a portrait drawing of their other boys."

Further Involvement with Joseph Floch

Following Joseph Floch's return to New York, Molly had sent him a few of her paintings for his criticism. He quickly commented on them as follows:

. . . First impression–great progress in drawing. I was surprised, in fact, to find the perspective correct and the proportions, in general good. . . . a clear conception of the colors and their organization is often lacking. . . Tonality is achieved when they are free and strong.

Gray, when it is not a live color and when it is not counterbalanced by other colors, kills the expression. Gray should not be used as a 'maid-of-all-work.' Avoid placing in a color, such as blue or yellow, gray shadows. The shadows are also colored.

I. The little painting with flowers. The composition is not very good, surface of background and table too much alike! Too much background–like a gray hole. Begin with a colored background . . . The green of the base is too gray and the table color not definite. The flowers, themselves, are right.

II. The Negress with the brown blouse. Here, also decision is lacking. Gray too much in the colors. The head is the best part.

III. The landscape with stream and bridge, with two little children. This is the best painting you sent. In the trees, the snow, and the ground, warm and varied tones and a happy contrast of the sky with its clear blue. The composition, also, is a very happy one with its development of the space. Only the foreground window lacks color and definition. You could have indicated, also, the window-frame.

IV. The landscape with the three children. Snow too gray and too like the gray in the houses. The children are good.

V. The head. Here you show great progress, but the yellow of the skin is a little heavy. The background color is good.

VI. Negress with table and lamp. Head is good, but here also the shadows full of grayed colors. You should have given the blouse a clear blue or green and indicated the shadows with warmer blues. Below the values too alike, those which are repeated parallel with the leg (a fault of composition). In this painting you show great progress in the technique of color.

VII. There remains the landscape with snow. Perspective good! The whole is a little too warm. In the grays there is a lack of surprise–of a color which gives a more lively impression. Snow color seems too warm. Some greens and blues lacking.

They used drawing to record the movement
of sensibility, as marks of mobility, of process.
This way of drawing lay behind the
work of the surrealists. From this germ action
painting in America was to develop.
"Myth, metamorphosis, risk, event-painting—these
liberating possibilities were little by
little impressing themselves upon the troubled
psyches of many New York painters,"
Dore Ashton stated in The New York School,
published in 1972.

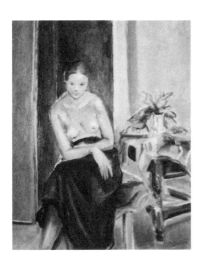

Figure in Interior / 1944

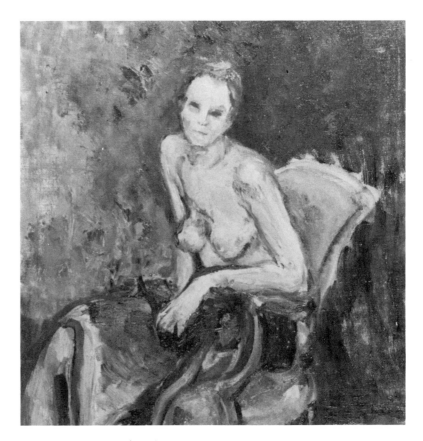

Seated Figure (detail) / 1945

Joseph Floch wrote later of the new collaborationist government at Vichy: "It is an end without glory," he said. "It has nothing to do with the real France." Then, at once, he inquired about Molly. "Has she fully recovered? Is she painting again?" And of himself, "I may make an exhibit of some canvases painted entirely in New York, my colors a little more direct and clearer . . . influence of the light here." . . . And to Molly herself: "Do you work a little? Don't forget that it was only six weeks I think that I have painted with you. This was only a first moment, and if I could see now anything of your painting I could say more. It would be perhaps possible to give you an impulse to continue the way which I have shown you . . . Affectionate thoughts."

Although wartime travel was difficult due to crowded trains and reduced schedules, Molly started going to New York occasionally to visit Joseph and work in his studio. If I did not accompany her for business reasons, she stayed at the YWCA and concentrated all of her attention on the work at hand.

In another letter Joseph wrote:

. . . and I have word that your life is going along tranquilly now. Amid nature where you live there is a calm interior of which we are also in need . . . in this enormous New York I am not yet at ease. There are a number of changes in our life . . . the children at home . . . the little one has suffered much in the separation from her mother . . . has failed to make progress. [The sorrow about this child was to be a lasting one.] *. . . Luck with the apartment matter . . . the Tietzes moving; we can have theirs, opposite a big park and very well situated. I will have a separate studio on Broadway. I have decided also to hold my show (October 11 to 30) at the Associated American Artists Gallery where the possibility of selling is greatest . . . Is it possible, dear Frank, to send me a letter somewhat official from the Art Additions Group which procured for the museum the canvas* Sitting Woman *for $350? They are asking such a letter in connection with the suit against the 'Navemar,' the terrible steamer by which we arrived a year ago.*

On October 19 in more cheerful tone came Joseph's announcement of the "vermissage" (preview) of his work the day before and proudly enclosing his first American catalog. "Thank you for the check from Mrs. Kountz," he added. "It comes in very handy, for I am at the end of my means and my only hope rests with the show . . . Happily I have a studio in a penthouse on Broadway from which I see all New York."

A letter from Joseph written October 14, 1942, told us that he and his family were "installed already in 119 Payson Avenue." In a separate letter to Molly in English he wrote,

And now, your paintings: your feeling of Nature is very fine. The skys are good painted, and also the perspective is exact; but the colours are too much mixed, not enough clear and organized. The values are too much equal. Please continue with some still-life. This will be a great help for you. The best painting is the little one with the street. I am sure that after few weeks, when we are working together, your progress will be big.
My exhibition is a real success and the gallery expects to sell some pictures.

Gottleib said, "During the 1940s, a few painters were painting with a feeling of absolute desperation. The situation was so bad that I know I felt free to try anything no matter how absurd it seemed . . . Everyone was on his own." (IBID p. 118, quoted from the Pollock Symposium, Art News (New York) April, 1967.) Molly Canaday was far from such extremes of feeling or action. During the 1940s she continued to paint still life and figures. However, there is a hint of difference in her drawings. They begin to vary from the direct transcription of Molly with Bangs and from the classical drawings of compositions taken from the Italian renaissance painters.

Violin Still Life / 1949

Home Musical / 1947

Figures in Interior / 1947-48

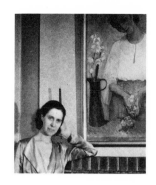

Joseph's criticisms in which he treated Molly as a fellow artist, with no slightest tone of patronage, stimulated her in all her work now. She showed a quick grasp of principles and his prompting, and was eager to send him more canvases for his comment. It was evident that we would seek an earliest possible opportunity to make a trip together to New York to have personal contact with him again.

During this same period Molly entered a contest sponsored by the Nierendorf Gallery in New York for the best definition of true art. Although Molly did not win the prize, her entry of her own *definition of true art* is worthy of note. She wrote in part:

Original materials of nature, including human nature, observed by the human beings of most sensitive perception, organized by the techniques which these true artists develop in the environment of their respective periods . . . addressed to the aspirations of all mankind . . .

AMID the self-imposed duties almost everyone accepted as part of the exactions of self-preservation, Molly worked on, drawing and painting assiduously in every available moment. After another lengthy visit to Joseph's studio she returned to Toledo and continued her sketching during some weekends spent in a rented cabin in the Irish Hills of Michigan. Returning from one of these excursions with a sheaf of faded reeds and dried out flowering plants, she painted them in an unusual *Winter Bouquet* of tawny tonality. She so thoroughly endowed this with all the skills she had acquired that the following year it

was awarded first prize for oils in the Area Artists' Exhibit at the Toledo Museum of Art. The Roulet Medal was presented by the mayor at an impressive ceremony held in the museum.

Thus the busy war years sped by until at last the Axis and then Japan surrendered, returning the nation to a welcome but strange kind of postwar experience. The America we all had known on Pearl Harbor Day had changed, and for Molly and me the return to peace also meant change.

As Joseph Floch's criticism and encouragement had become increasingly important to Molly's progress, it was now apparent that she should study under him full time if possible. Thus this need became the dominating influence which led to our move to New York in 1947. It fitted well into my own plans too, for I was ready to quit my demanding job and use some of our savings to satisfy my ambition to study and write fiction. After fourteen years in Toledo we said our farewells and started for the East Coast, with hopes of furthering our respective careers.

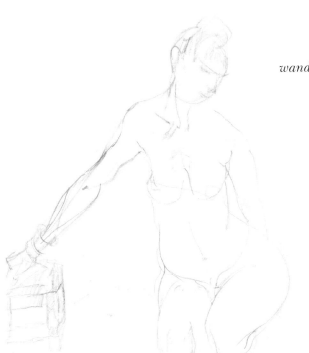

*There are sketchbooks full of
drawings, little comprehensible by comparison;
drawings which seem ineffectual,
wandering, a net of lines. Sometimes out of the knots
come a real shoulder, a sag of stomach, the
bulge of a thick thigh. Drawing
was becoming the evidence of a struggle. She
was trying to relate the lines, not just
to what she looked at,
but also to her feeling for what she saw.*

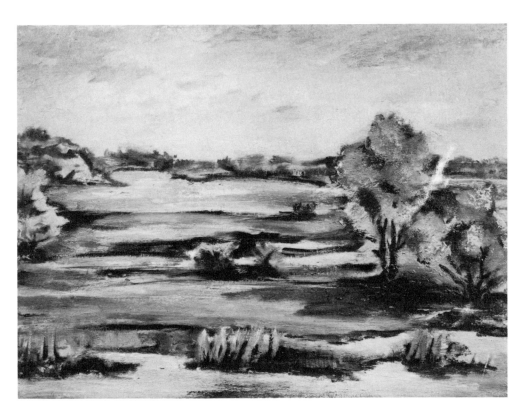

Ohio Landscape / 1949

4

The Floch Period

ACCEPTING a tiny fifth floor walk-up flat in crowded postwar New York of 1947 we improved our situation after an initial move into the upper edge of Greenwich Village and lived for a few years in somewhat better quarters in a fourth floor walk-up studio on Washington Place. There a skylight provided Molly with an improvised painting area in our living room through the day, while I worked at a card table in the bedroom writing short stories and, eventually, a novel. Molly prepared the meals and we shared the other domestic services and household errands, but she also found time for many hours of work in Joseph Floch's midtown studio off Lincoln Square, advancing professionally to the point of doing some exhibiting in New York and elsewhere.

INSPIRED BY VIEWS from her apartment studio windows in lower Manhattan, Molly painted a series of urban rooftop paintings showing skill in dealing with complex geometrical forms and perspectives. There was a touch of sentiment in one of these containing a contemplative human figure, perhaps representing her own wondering spirit as she attempted to absorb her new environment. "Humanity, alone still, amid all the vastness and complexity of its works" might well express the universal aspect of the theme that dominates these first New York landscapes.

A pattern of our normal participation in cultural offerings and entertainment of this and subsequent years is represented in the mention of some of the events we attended during the first week of April, 1948: a free Sunday concert in the Frick Library music hall; a Monday matinee of a ballet; a Juilliard orchestra recital of Bach's *Passion According to St. John;* dinner and evening with my eldest brother and his wife and a Stravinsky concert at Town Hall, with many intervening quiet evenings at home.

Literary agent Franz J. Horch, a friend of Joseph and Mimi Floch, had agreed to handle my writing output. He wrote me,

I have immediately read your short story entitled The Idol *which, in my opinion, is not bad at all. I have tried to find a place for it right away. Let me know Miss Jordan's verdict and should the novelette come back, don't forget to send it to me.*

Some weeks later Joseph and Mimi invited us to meet Horch and his wife at a supper in their studio. We awaited them for drinks, then had ours, and still they did not come. Joseph finally made a phone call and came back looking distressed. After a few minutes' dissembling, he gave us the bad tidings. My agent had died of a heart attack. This man was serving some of the most distinguished writers of contempo-

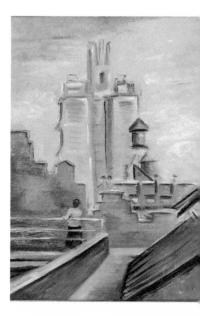

rary Europe. His continued interest in me and guidance might have made the difference between success and discouragement.

Subsequently in my own endeavors at fiction writing many publishers offered the very kind of technical aid that I had constantly encouraged Molly to accept in her own field. In spite of this assistance the great American novel never materialized and I bowed reluctantly but inevitably to "forces majeures."

Greenwich Village Rooftops / 1946-47

The Vermont Experience

In midsummer 1949 my eldest brother Ward offered a tempting respite from city heat in a house he owned in South Woodstock, Vermont, which was temporarily unoccupied. "Upwey" was a large rambling country residence surrounded by a lovely formal garden. The house was so dominant on its hill amid the smaller habitations of the hamlet below that it was known locally as "the mansion." We settled in gratefully among the cool Vermont hills and employed the opportunity to have some relatives and friends as guests, among them Mimi Floch from New York, for some days of relaxation with her mentally unfortunate younger child.

Joseph Floch's letter of July 28, 1949, came to us soon after Mimi's visit, appreciative of having received from her assurance that she had been "very relaxed." In this, as in any letter to either Molly or me, he never allowed his own news to displace his enduring concern with Molly's progress in painting. In this one he also wrote, "I found good color crayons (like pastel, but fix) and

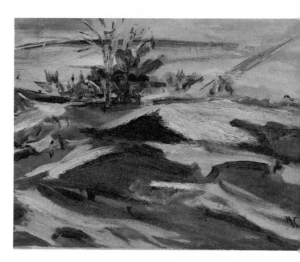

Upwey Farm Spring Snow / 1950

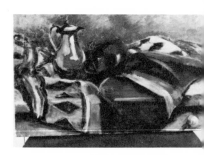

Still Life with African Mask / 1948

In 1946 the Canadays moved to New York and Molly Canaday became one of many artists to be enlivened by post-war New York. The painting Greenwich Village Rooftops *shows her first reaction to this new environment. One of the reasons for their move had been for her to work more closely with Joseph Floch. All her paintings of people and her still life studies of the late forties echo this association. She uses thin isolated figures in interiors in Floch's manner, restricts herself to his range of cool blues, umber and dull red, and gives little indication of having any real feeling of her own for colour.* Still Life with Black Plate, *painted possibly as late as 1951, is an assured composition but one still dependent on a student role, on a lack of confidence in her own vision.*

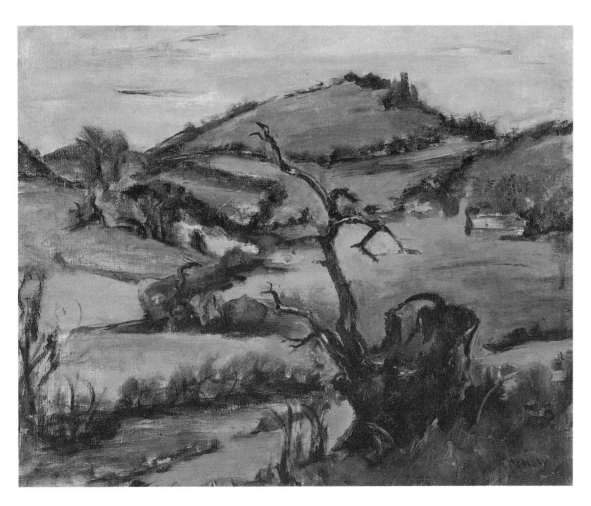

Vermont Valley / 1951

I think Molly would like them. I will send a box. (Good for quick sketches and notes.)"

He then said that he had seen the Tietzes in Austria, and a month later we had a letter from the Tietzes written in Seefeld, Tyrol, in which Hans remarked upon their impression that our vacation in Vermont was overcrowded with family visitors. He and Erica shared instinctively with Joseph the concern that social intrusion or other diverting circumstances might produce in Molly's life, as in that of so many other aspirants, a discouragement leading to the abandonment of her creative effort.

This concern could not but remind me of the episode wherein Molly had told Nona she felt like the tree which constant hill-top wind had bent over nearly to horizontal. Nevertheless, I was confident that she was long since over any such feeling of repression as this remark of her early days may have represented. I had no current cause to feel worried that she would become discouraged or abandon her artistic endeavors. Somehow she was learning to cope with the relatives and friends whom we entertained so regularly and she often took advantage of such occasions by using the visitor as a model for a quick sketch or two on her pad for possible later use.

It was evident, too, that she was beginning to look forward to Joseph's verdict on these sketches and her other summer's work. She spent long hours at her easel by a window in the upper hallway of the mansion. There almost every visitor to the house was sketched. Between guests and gardening, Molly was zestfully recording with pencil and brush the new revelations of countryside and people of the different world now about her.

Vermont Valley / 1950 (detail)

wey Landscape / 1950

A change to a more mature assurance came after 1949 with the first of many summer experiences of Vermont landscape. They went to holiday in a relative's farm house. Molly was so happy there that they returned to the Green Mountain state each summer for the remainder of her life. Molly Canaday had needed to work away from the armature of a teaching studio. She found in Vermont a landscape which moved her and the confidence to see with her own eyes. With a spate of painting she celebrated Vermont, trees shading dirt roads, slow curves of forested hills and wide valleys, apple trees magically laden, enclosed pools and confusion of sapling trunks and branches, mist and soft colours, large simple shapes of dark barns and white wooden houses. Upwey Farm Spring Snow *has the simple restraint of a haiku.*

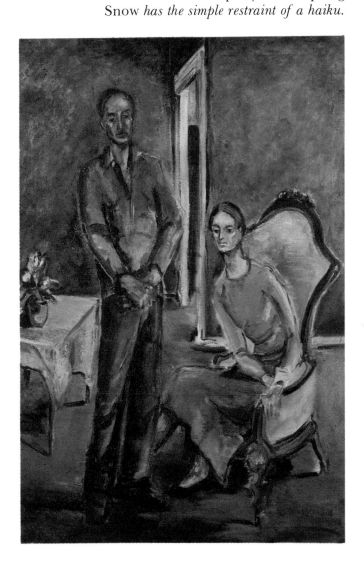

The Vermonters / 1950

Upwey

Too busy with all this to write letters regularly, Molly felt no surprise nor deep concern when a letter from Joseph queried anxiously again: "Does Molly paint? Should not she have two or three hours free for work? Her progress was always from day to day earlier visible." He gave her much encouragement in reporting that Kopf (Czech painter and husband of Dorothy Thompson) "liked her work very much." He closed with the encouraging comment that "Molly's work is personal, and better than many of the well-known painters in New York. I hope that Molly has enough time (some hours a day) to continue."

Continuing, indeed, she was able to assure him, and that fall she proceeded as in every following colorful October to attempt to convey in paint something of the overwhelming magnificence of the Vermont reds, browns, yellows, and oranges with their mingled accent of evergreens spread in illimitable expanse across the hills and valleys. In this first year of such art adventure there was rarely a canvas that she considered even a meager approach to success.

However, this Vermont experience, now seemingly coming to its end, had been from its beginning an inspiration to us both and was to have an unforeseen far-reaching effect upon the advancement and range of Molly's painting. Imagination had stimulated her work there in a very personal and special way. She worked outdoors as much as possible in every season and though at one point I rented her a nearby guest house for a studio she continued for the most part a preference for painting in the open. She was to experience a new inspiration to her

emotions and her ambition from which was to come, over a long period, a new artistic advance, especially in the increased sophistication that entered her painting of human figures.

Indications of Increased Sophistication

In spite of the diversity of events that crowded our calendar during 1949, Molly spent many intervals of concentration on her painting in Floch's studio, independently at home or about the city, as well as in Vermont.

A move into any new environment had the effect of stimulating her imagination and spurred her to sketch or paint any willing living subject encountered. The weeks of the 1949 summer during that first year in Vermont produced a new advance particularly in the increased sophistication which showed in her painting of human figures over the next several years. One such canvas was of a neighbor girl holding a cat, conveying elegance of person in the model and an appreciation of elegance on the part of the painter. Another was a small oil on canvas of a *Seated Girl in Red Dress,* endowing the model with a depth of personality that I felt profoundly successful in stirring the imagination.

On a larger canvas (18x22) she painted a *Seated Figure on a Blue Couch.* This was an engaging composition representing a further mature grasp of the subtleties of colour. These she had developed not only in attainment of atmospheric quality but also in the convincing representation of the features of the human face. There was

By 1951, in looser paintings of the Vermont
Valley and the Valley of the Kedron, she
is interpreting this increasingly-known landscape. The
effect of a counterpoint living between the green space
of Vermont woods and the apartment in New York may
have helped her to separate out the coloured crystals of
her experience. It certainly led her to fuse the Floch
stereotype with Vermont life in two paintings, The
Vermonters and Woman Reflecting in a
Wood and, later, in Woodland Patterns
with Two Figures.

The Vermont couple, the subject of the first painting,
are handled in the Floch manner and colour, but here
Molly Canaday interprets the figures individually. They
are people who work on the land. Thin figures,
separated from each other and withdrawn into a quiet,
sad acceptance. The man stands, the woman sits, in
angular yet relaxed heaviness.

Figures in Studio / 1952

Rugged Vermont Woodland / 1952

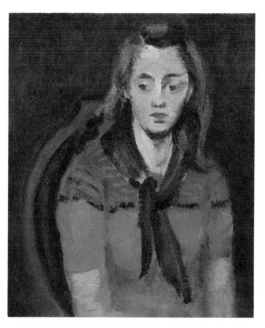

Seated Girl in Red Dress / 1951

grasp also of further composition techniques, especially in the placing of the figures solidly in depth. The handling of lines and color was firmly directed toward producing a meaningful pose contributing to the creation of a human personality imbued not only with sentiment but also with a contemplative depth of character. (This painting was included by the contemporary curator of the Toledo Museum of Art in his selections for the posthumous retrospective of Molly's work there in 1972 and, as an item in this collection, was exhibited throughout New Zealand after adoption into the New Zealand National Art Gallery's permanent collection in Wellington.)

Molly's several still life studies of this year also gave evidence of this new sophistication. Particularly noted was her use of an interior background which presented a painting within a painting, and her increased use of opposition in lines for occult balance.

Alluring to every painter through the ages has been the emotional metaphor of stringed musical instruments. This is especially true of the violin form symbolizing the popular companion art and the challenge of representing it with fidelity in paint while conveying the creative element of an aesthetic work of art. So it was with Molly's early work in Floch's studio when she borrowed a violin and made it the foreground object in a still life arrangement to which she added the violin case, its forms related but providing at the same time the interest of oppositions both of line and color. A background complexity was added to the composition by including a small replica of a former painting.

As part of her success in this work she established a sense of depth which seemed essential to a flower-in-vase subject alongside the violin on a table top. An enlivening element of urban landscape was introduced to include an impression of distance with the glimpse of a tall building through a window, an informative and pleasing contribution to compositional balance.

Refusal To Be Enigmatic

On one of her early visits to New York, Molly was introduced by Floch to the Pierre Matisse Gallery at the corner of Madison Avenue and 57th Street, and thereafter esteemed its reliability for "exhibits always worth visiting." The clipping of a *Times* criticism of a 1946 one-man show of Chagall's current work seems likely evidence of her having first absorbed (later to reject) the comment that "once you are thoroughly familiar with this artist's brush whimsicality there is little more to learn."

Although the critic concluded, "Radical change need not be looked for, only variations on expected theme," I am sure that Molly never ceased to be charmed with this Russian Jewish expatriate's canvases, however valid the critic's harsh view that "the walls now hold new canvases, but most of these look very much like those that have preceded." He had failed, however, to make mention that in most of Chagall's canvases chosen for exhibit the commercial galleries were obsessed with the one feature of human figures represented as floating unsupported in midair.

He did allow, on this occasion, for having observed in *Cheval . . . ton Reve*, one device that he did not recall Chagall's having previously used, "a transparent violin." "We have the perennial brides and grooms," he persisted, "sometimes up a tree *(L'Abre)*, sometimes in fuller levitation, the blue or yellow donkeys, etc."

Molly went on enjoying these protagonistic themes and discovering many of very different variety through all the years till her faith declined with her first view of the Chagall murals commissioned as the spectacular double frontispiece of the new Metropolitan Opera in Lincoln Center. There, she felt, in attempting to repeat his triumph in the Paris Opera his ebbing energies had failed him.

Coincidental with the 1946 Chagall show at the Pierre Matisse, a characteristic exhibit at the Solomon Guggenheim Museum on East 56th Street of "non-objective" work of several contemporary artists was rated by one critic as "in some degree enigmatic . . . Most of the artists," he said, "derive from each other, but if they derive in the slightest degree from the realm of everyday nature, that unorthodox method is effectually hushed by the playing of recorded music . . . This art," he concluded rather sarcastically, "is pure non-objective art" . . . and added, "Often elsewhere I have taken abstractions to be *non-objective*, only to find that they had their origin in objective visual experience."

New Zealand trip . . . 1950

This Molly must have recognized as paralleling her own experience. However, she seldom missed a visit to whatever was shown in the controversial new Wright palace so originally designed to house its art offerings. Though she approached use of non-objective principles judiciously and acquired skill in tasteful employment of abstraction, her work was always characterized by a definite avoidance of any conscious attempt to be enigmatic.

An Eventful Year

The year 1950 was especially eventful for it marked three important milestones for Molly.

During the first two weeks of June Molly had her first Vermont one-man show at the Dudensing Gallery in Woodstock where twenty-three paintings were exhibited. The pictures were carefully selected so that the showing would be representative of what she had painted to date. Titles ranged from *Mawmee, Ohio* and *Flower with Ship* to *Vermont Hills, Evening Snow,* and *Bellows Falls.*

That summer we purchased a small cottage which we named "Cleftwaters," paying tribute to the stream which paralleled our wooded private road. Situated not far from South Woodstock, this was to become our Vermont summer home for the rest of our lives together.

New Zealand Thermal Pools / 1950

Finally, Molly made her first trip home since before World War II, traveling with her sister, Erica. The sisters went by boat, visited friends in England, and Molly then stayed in Paris where she saw Joseph Floch in his "charming left bank studio." Writing to me of this experience, she said in part:

Joseph has been just marvelous. He spent all Saturday with me and then the afternoons of Sunday, Monday, and Tuesday. He insists on putting me on the train tomorrow. Through his guidance I have seen things I never would have seen alone. The beauty and life of this city and its collections are beyond belief. I even saw a wedding at Notre Dame this morning so that the great old cathedral came wonderfully alive with the ceremony and music.

After rejoining Erica in London the sisters sailed through the Mediterranean, the Suez Canal, on to Ceylon, and eventually to Sydney, Australia, and New Zealand. Molly's excitement at being home again was reflected in the following excerpts from letters I received:

The landscape around Wellington is quite thrilling. The greens are more wonderful than any I know. It's been warmer the last few days, so I've been out for hours looking and sketching and I'm delighted with the possibilities. It makes me feel much better in myself to be working again. It's become a necessity to me . . .

I've been quite daft about the beauty of Wellington. It needs a great painter. It's wonderful as I walk around. I feel quite happy with the beauty. It's not only the hills, but the marvelous colours and textures. I long for a car to get around. Pat says if you could bring a car down you could pay for half your trip.

Unfortunately, I was unable to heed this suggestion as I rushed to join Molly that fall. She met me in Aukland early in November, and after several hectic weeks traveling and visiting her countless relatives and friends, we embarked on December 12th for the long voyage home through the Pacific and up to Vancouver.

ARRIVING FROM a frigid train trip across Canada on our journey back from New Zealand in 1951, our return to New York was so discouraging that we could only pick our way sadly through narrow passages between household possessions stacked mountainously floor to ceiling. There we sat on the one accessible bed and laughed at the impossible situation in which friend Oliver Williams had placed us because of his anxiety for his sister. We had rented our studio apartment at 126 Washington Place on condition that we would relinquish it to his sister in the event she should ever lose her lease. Unable, apparently, to postpone evacuation of the condemned building in which she had lived and had her studio, his solution was to move us into the only available apartment in another of his buildings at 55 Morton Street. That we should be so summarily moved out without preliminary negotiation and stacked up in a place infinitely too small for our possessions was beyond all our calculations. It required a week of inching maneuvers to make our shelter barely habitable.

To Oliver's credit he eventually rented us a spacious parlor floor in an elegant old house near the harbor front esplanade on Brooklyn Heights with a magnificent view of the towering Manhattan waterfront. We moved into its spacious, mahogany paneled elegance with a more than audible sigh of appreciation. Our stay here was to prove one of the most enjoyable and productive periods of our whole New York experience.

During that summer of 1951 Molly achieved her first recognition in important national shows, her canvasses being accepted in several New York exhibits. In the annual show of the National Association of Women Artists, hers was one of 150 canvasses exhibited out of some 2,000 submitted, and one of the half dozen cited in the awards.

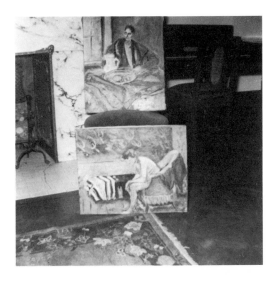

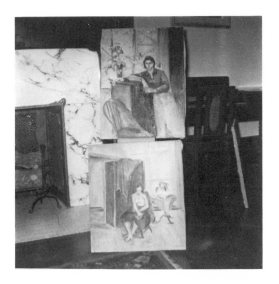

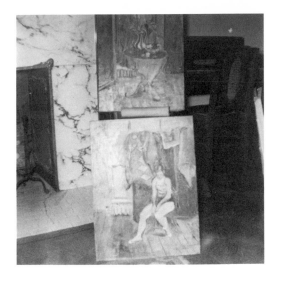

Keepsakes of an Artist

The articles we clip, the pamphlets or books we set aside to be reread at some later date, the mementos we tuck in bureau drawers to be enjoyed from time to time, are often indicative of our secondary interests which may not be apparent to others. After Molly's death I discovered numerous keepsakes and mention a few to indicate some of her interests beyond the easel.

Of extraordinary interest to Molly and to me on our return to New York, as well as to the Flochs and the Tietzes who knew Germany's painter Kokoschka in their Vienna days, was a comprehensive showing of his watercolors by the Feigl Gallery on Madison Avenue. Some of his figure paintings were so trenchant that they seemed almost frightening in their penetration: *Maureen, Doris, Girl by the Tree Reading,* for example. There were also potent still lifes of wide range and arrangements: *Fruits and Sliced Melon, Grapes and Peach, Corn and Lemons,* to name but three.

Cleftwaters beginnings . . . 1950

Molly had kept the catalogue sheet with its black and white reproductions in the drawer of remembered treasures in her studio bureau. She also saved (along with studio keepsakes of 1949-1950) a page torn from a Greek magazine reproducing a painting of an infant dozing with lips upon the nipple of a breast, a possible influence upon the handling of the portrait she made later that year of Alexis Hook's baby. She had clipped certain reviews of books of the day, among them *Genius and the Mobocracy,* a volume commenting upon the theme expressed in a phrase, "Eminence in architecture is no guide to political competence," and a Phaeton Press book issued by Oxford University Press, *French XVIII Century Painters,* by Edmond and Jules de Goncourt.

Lastly was a clipping from the pages of *The Saturday Review* with a marked guest editorial on world government titled: "Our Manifest Destiny," by the Margaret Byrne Professor of History at the University of California. It opened with a quotation from Justice Holmes: "What we need is more exposition of the obvious and less elucidation of the obscure." Its theme was that as the world's biggest confederation of democratic states, the most powerful champion of individual freedom, yet possessed of the greatest war potential and so long a non-joiner nationally by temperament, the United States would surely have a manifest destiny "higher than our forefathers talked about a century ago." This was a destiny Molly seemed to surmise we were obligated to assume in taking a basic lead in the movement toward world government.

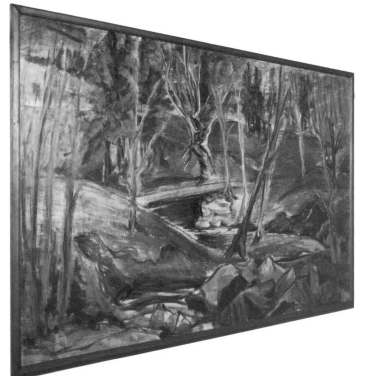

Cleftwaters-Woodland / 1953

Making of Cleftwaters / 1951

European Trip of 1954

There were two reasons for our trip abroad in 1954.

First, it was an ideal time to be in Greece while Molly's oldest sister Nona was still living there. Nona, representing the United Nations, after the war had worked resettling deserted Greek children and was asked to return so she might teach Greek women to carry on the work she had started. Recent letters from her warned that she would not be staying there much longer, hence we thought we should take advantage of her warm invitation to be our guide before it was too late.

Second, during my 1932 courtship in London I had promised Molly that if she postponed her then-scheduled first visit to France, so we might be married sooner, I would make up for the omission with a trip for us at a later time. In some twenty-five years I had not managed to accumulate either time or money to fulfill the promise. Finally, I was in a position to take her on this long overdue trip.

Sailing on the Italian ship *Andrea Doria* on February 4, 1954, we touched at the Azores and Gibraltar, then disembarked at Naples. After excursions to Sorrento and Pompeii we went to Rome where Nona met us and conducted us about the principal sights familiar to all tourists, the outstanding attraction for Molly being the Michelangelo frescoes within the Vatican.

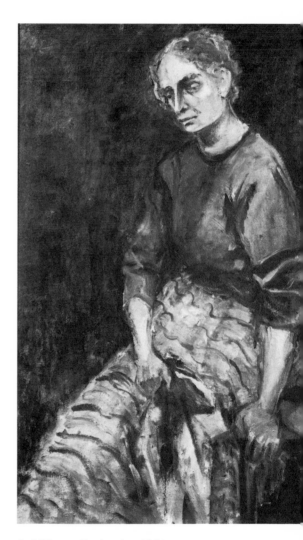

Sad Woman Resting / ca 1954

In Girl with a
Violin, Girl with a Cat, Sad Woman
Resting, Head of a Young Girl, Head of
Alexis *her figures have the remote, sad quality which
she had more awkwardly expressed in her earlier
paintings of people. These are thoughtful honest paintings,
grown from her own life.*

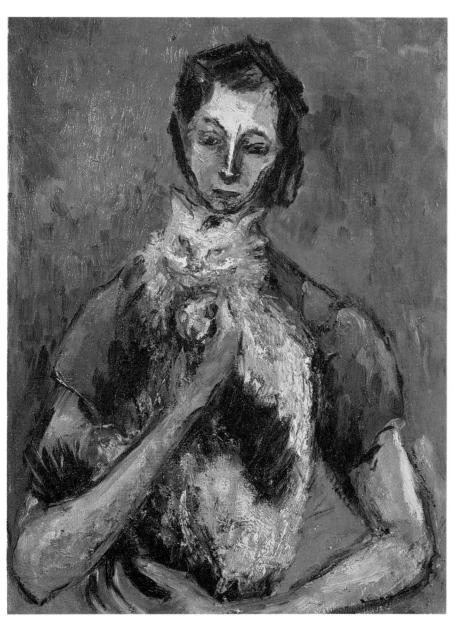

Girl with a Cat / 1950

The boat journey from Brindisi to Athens took us even further back in time. Here we saw many great buildings from earlier centuries, structures in which Molly's interest was heightened by the frescoes and other paintings done by famous artists. Nothing brought from her such expression and wonder as when she stood by the city-level temple of Zeus and looked up for the first time at this architectural wonder, standing serene and aloof in the evening light above the modern center busy with movement.

During our stay in Athens Nona introduced us to a friend who painted under the shortened name of "Ghika." We purchased a landscape from him which the artist asked Mrs. Bernard Gimbel (wife of the well-known art collector and New York retailer) to ship to New York together with some other paintings she had purchased. The result of this courtesy was that Molly had the privilege of visiting Mrs. Gimbel in her home near New York and seeing her own fine collection of paintings.

Nona's personal guidance was particularly valuable to us, making it possible to encompass in a one-week motor trip a view of the principal historic and artistic features of the Peloponnesus. As we proceeded through hills, their barren tops emerging above the teeming rural life below as it must have been two thousand years ago, the road was busy with the passage and mingling of old-type, donkey-drawn vehicles, donkeys, goats, and sheep (with Jason's golden fleece) being herded and tended.

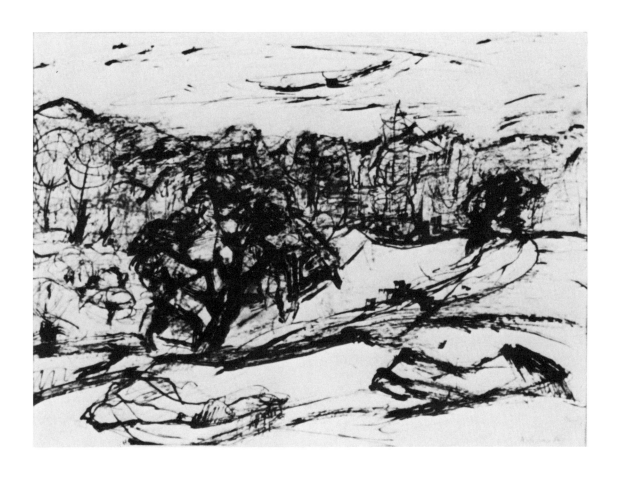

Agonetti's lithograph "Mountain at Maloja"
(top left), acquired by the Canadays in 1950,
and two subsequent Vermont landscape studies
completed by Molly Canaday in the early fifties

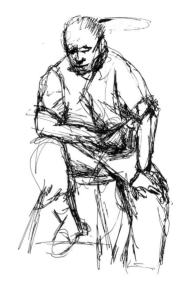

Then there were Corinth with its sculptures and frescoes of the later millenniums; Mycenae, famed for its Lion Gate still standing where Agamemnon returned from Troy to his Clytemnestra; Sparta, seeming so small amid its hills for a place once so celebrated; Thebes, Delphi, and at last Piraeus, for the ocean-ferry trip back to Brindisi.

Motoring northward through Italy we passed through countless towns previously unknown to us, but wherever there was something of interest to Molly we took the necessary time to view it. Arriving in Florence we quartered at a recommended pension where our window looked down upon a walled-in garden, and we discovered we were within easy walking distance of the Uffizi Gallery. We visited here almost daily during our week's stay in order to give Molly repeated opportunity to view for the first time and at close range many of its seemingly boundless collections of world-famed originals by Fra Angelico, Botticelli, Raphael, and others of celebrity.

Even closer to our pension than the Uffizi was Florence's most important public collection in the Petit Palace, and in the city's center the superb Bargello with its historic treasures. Near it were other famous remains of ancient Florence with its richly embellished cathedrals and palaces. Side trips from the city completed our week's stay whereupon we went on to Venice. Here Molly looked forward especially to seeing that part of the Grand Canal and adjacent regions which had inspired painters through the centuries.

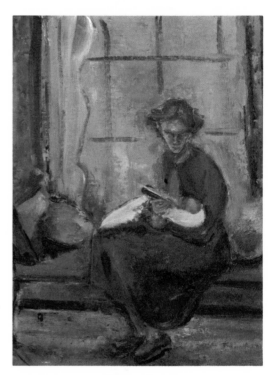

Alexis with Baby Edith Ann / 1949

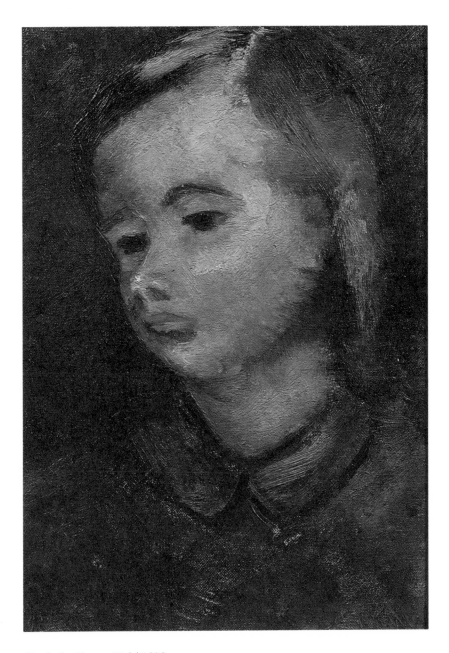

Head of a Young Girl / 1953

Northward once again, we crossed the border into Monaco and out again into France where we stopped in Vence. Discovering we had missed the weekly visiting day for the little chapel in the nunnery where Matisse had painted a fresco (after being nursed through an illness there), we rose early next morning to attend service with the few remaining nuns and looked upon the frescoes during intervals of the Mass read by a patient old priest.

Avignon, Vichy, and across the Pyrenees into Spain; Gerona and toward Barcelona, thence to Sitges and a day's visit in Tarragona, an ancient walled city. Here we spent several interesting and profitable hours with some artists who had introduced themselves to us at our hotel during lunch. In a city with such an evident cultural heritage these artists, whose studios were in the more obscure quarters, displayed a current creativity which was especially exciting to Molly. It was stimulating to discover that these painters, surrounded by and steeped in tradition, nevertheless were experimenting and imaginatively following their own ideas and inclinations.

Madrid, Avila, Salamanca, and Palencia were next on our itinerary and afforded Molly a final view of Spain's vast treasures of ecclesiastical art. Then up into France through Biarritz, Bordeaux, Poitiers, to Paris, where we spent several hours looking at the collections of the Louvre, and visiting the Sorbonne as well as numerous cathedrals and galleries. A quick detour took us to London, Canterbury, and Winchester, and we were back in France again by way of the channel ferry for our departure by steamer from LeHavre.

Art Treasures Viewed By Molly

Greece

Byzantine sculptured treasures: ATHENS — Parthenon, Temple of Zeus: MYCENAE — Lion Gate, Royal Palace

Italy

ARIZZO — Piero della Francesca frescoes; ASSISI — Giotto, Cimabue, Simone Martini frescoes; FLORENCE — Uffizi Gallery (Botticelli, Fra Angelico, Raphael, etc.), The Bargello, Michelangelo sketches, Byzantine mosaics; NAPLES — Byzantine Museum Pompeiian frescoes; PADUA — Giotto paintings; PERUGIA — Perugino paintings; PISA — Benozzo Gonzoli drawings; ROME — Michelangelo frescoes, St. Peter's, public buildings; SIENNA — Lorenzetti's paintings and those of other native artists; VENICE — Titian, Giorgione, Tiepolo and paintings of other artists

Spain

MADRID — Prado collection (Goya, de Ribera, Velásquez, etc.); TOLEDO — El Greco paintings

France

BOURGES — Cathedral, ecclesiastical art; LASCAUX — Prehistoric cave paintings; PARIS — The Louvre, various galleries and cathedrals

Throughout this trip our interest everywhere had centered on studying history and looking at art and historic sites through paintings, sculpture, cathedrals, historic buildings, and galleries. It was an overview primarily of Greece, Italy, and Spain. During these weeks when Molly saw the best of the art world in each of these countries she never tired or lost her enthusiasm, nor did she experience disappointments, because of the lack of opportunity for any sketching or painting of her own.

Although most of the trip was concerned with viewing Europe's art treasures, Molly had contact here and there with contemporary artists, especially in Spain. This experience doubtless precipitated her gradual move toward artistic independence for it challenged her imagination and desire to strike out on her own, proving an important milestone in her artistic development.

*The Vermont landscape observed and meditated about
became the source of Molly Canaday's mature painting.
The Canadays bought a piece of land in the woods near
Woodstock and began to adapt the small house there,
"Cleftwaters," into a summer home with room for
friends to stay and an upstairs studio. There was a
stream nearby and a tangle of young trees which can be
seen in the paintings* Cleftwaters Woodland,
The Making of Cleftwaters *and* Rugged
Vermont Woodland. *In* Rocky Meadow
and Vermont Autumn *the essence of this wider
landscape is distilled.*

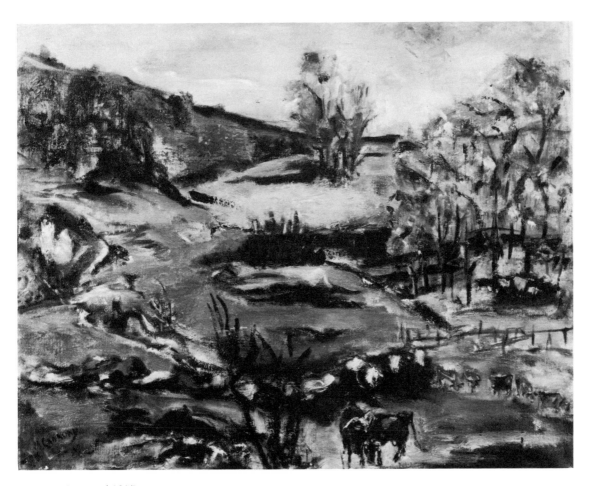

Vermont Autumn / 1957

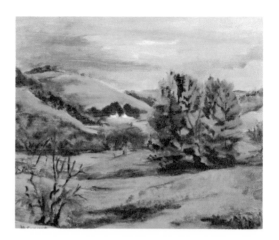

Wellington Harbour / 1952

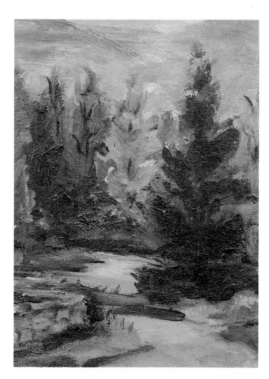

Upwey Pool / 1949

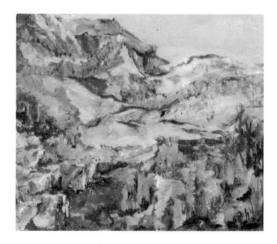

Green Mountain Landscape / 1956

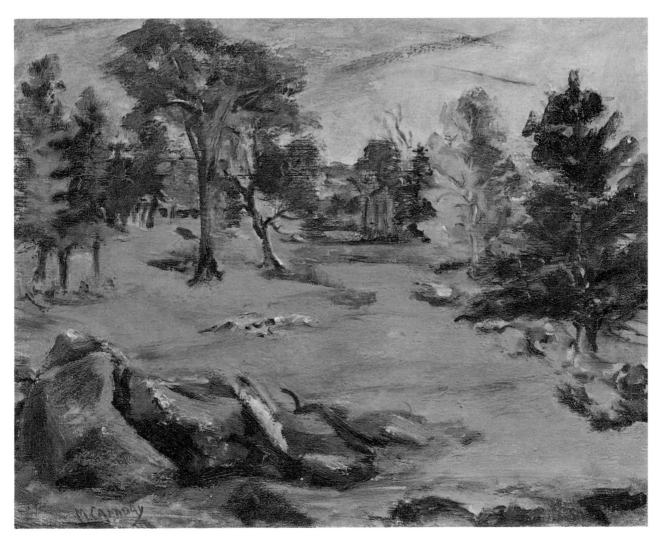

Rocky Meadow, Vermont / 1952

O N OUR RETURN from Europe toward the end of 1954, we moved from Brooklyn Heights to Murray Hill in midtown Manhattan. Our new residence made it more convenient for Molly to reach Joseph's studio as well as visit the older galleries of 57th Street and numerous new galleries ranging uptown on or near Madison Avenue and which were becoming increasingly important to her. That she was working steadily at her art, producing oil paintings and some watercolors, is evident from a letter written to her in the autumn by Lynn Kottler of the Lynn Kottler Gallery on East 57th Street:

"It is my pleasure to inform you that we are very pleased to consider your work for exhibition in one of our forthcoming shows . . ." There followed a routine promise of efforts to obtain publicity for its shows and reviews by critics, and the terms of its usual contract. Though a commercial gallery of good standing, it made only minor contribution to artist prestige and her exhibiting there brought no results. This experience strengthened, I am sure, her preference for entering only galleries or shows of a different character when she took any time from her easel to exhibit at all.

However, from her new central location she visited independently and with wide selectivity more of the contemporary exhibits than she had ever seen before. She no longer felt the need to defer to Joseph's distaste, whether he expressed it in words or by his evident repression.

In retrospect I can say that Molly was not basically concerned when she was in disagreement with much of Joseph's adverse view toward contemporary shows. She merely wanted freedom from prejudice in her approach to the contemporary exhibits, whatever their character. Her work of this period and later bears witness that, though she treated with restraint the extremes of the contemporary cubists, abstractionists, and experimental presentations, she was extremely selective in adapting their procedures in her own paintings.

She continued faithfully and always with interest to visit Joseph's studio, but mainly attended his weekly group classes. Later she leased a studio neighboring Joseph's to which she went for gradually increasing periods. In 1955 she was conceiving (perhaps only vaguely in her unconscious mind) a withdrawal from Floch, not only to achieve detachment from his influence in the study of contemporary works but also to be independent from all outside direction in planning and executing her own work.

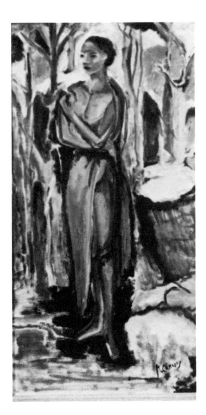

Figure in the Woods / 1953

Woodland Patterns with Two Figures / 1953

95 / *The Floch Period*

The Drift From Floch's Critique

Molly's five years' residence in the Murray Hill apartment had brought a transitional independence in viewing contemporary painting in all its norms and extremes, and 1959 proved the culminating year of a gradual withdrawal from all formal tutelage and influences. She had felt she must handle her withdrawal with special care and deliberation in relation to Joseph. She had been greatly concerned that as he recognized any move toward detachment from her long and close professional association with him, their personal friendship must be protected and fully maintained. If he was to show resentment, she counted on his acknowledging that such a transition was wholly natural in artistic tradition. This she knew might take a little time for Joseph to concede even to himself, as he had for so long proudly contended that he could teach techniques without imposing his own style. However, in Molly's case, from the start of their acquaintance he frequently mentioned his relationship to her as a fellow painter rather than teacher, her benefits to be derived mainly from regular observation of the work of an artist of longer and more mature experience than herself.

She had accepted as ineradicable Joseph's strong prejudice against the main trend of contemporary exploration. Now it was a readily available explanation of a policy of withdrawal from his active counsel or criticism. She had not long to await confirmation in his assenting to conformity and that it should have no bearing on the continuance of their close friendship throughout life.

Joseph's appraisal of her achievement then and his concept of the part he had played in her accomplishment to that time was expressed with accuracy and conviction in his page contributed to the catalogue of the Toledo Museum's commemorative retrospective of her paintings in 1972. This expression of his established and lasting esteem for her as an artist and a friend could have been written as well in 1959 as a dozen years later.

It was in November, 1941, through my Viennese friends, Hans and Erica Tietze, that I first received an invitation to visit Toledo and paint the portrait of Molly Canaday. From the moment of our meeting, Molly's charm of spirit and person made the project attractive, and with such a model for inspiration, I felt constantly more confident of the portrait's success.

Only after several days of work and talk and observation of her background did I learn from Molly that she, also, painted. It came as a complete surprise, and brought new delight to the friendship, to realize that it was she who had done the flower studies and landscapes on the walls, which had attracted my interest and which I had vaguely been seeking to relate to the work of some of the artists I had known in France. So, from these earliest days of our acquaintance, it was clear that Molly was a person of talent, with a fine color-sense and an instinctive feeling for space and volume and for expression of each nuance of light . . .

*Molly Canaday was fascinated by the Quechee River
Gorge near Woodstock and did many drawings of the
area around the bridge which she brought together into*
The High Bridge Over Quechee Gorge
in 1954-55.

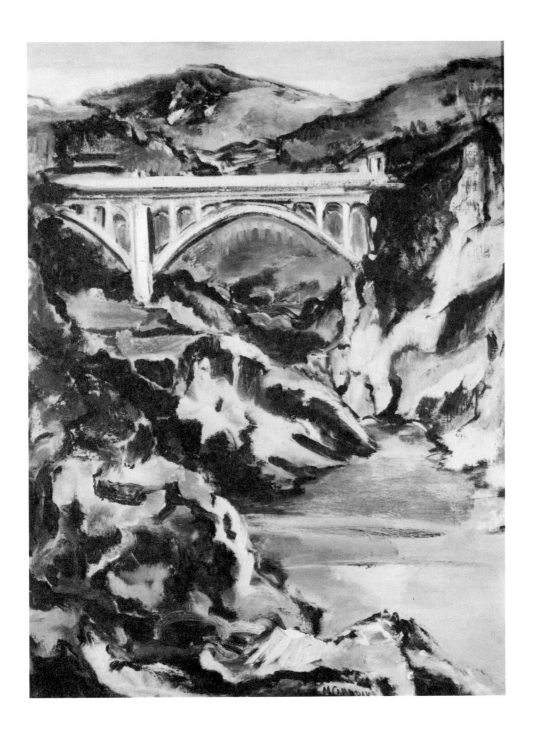

The High Bridge Over Quechee Gorge / 1954-55

So our talk, during the further 'days of the portrait,' turned eagerly to painting, and later, by letter from New York of criticism of paintings she sent me, I sought to give her work further advance in the areas where her practice had been insufficient. During some following years, when she came to New York occasionally for brief periods of work in my studio, I felt that my suggestions and criticism, along with my encouragement to more practice in drawing, were giving her constantly greater confidence in her talent and bringing her progressively along the road toward full realization of her possibilities as a painter. Her later move to New York with her husband brought her regularly for work in my studio. This gave me, over a number of years, the greater opportunity to have what, I am proud to think, was a larger share in influences that helped her bring her artistic talent to maturity. While she was with me each week in my studio, she painted as a real fellow-painter things that she loved, flowers and objets d'art, interiors, and figures – and all the time she was working hard to find her own way, to find her own personal style in representing objects, personages and landscapes. I am happy to think that I helped her to discover the technical possibilities of expressing what her spirit prompted – assisted her in speaking her own language in paint . . .

Toward 1960 her work moved more and more definitely into abstract conceptions. Here her sense of color harmony and the advanced training she had achieved in design were of particular help, as her painting of the '60s in the present exhibit so fully demonstrate.

Woodland Stream / 1953

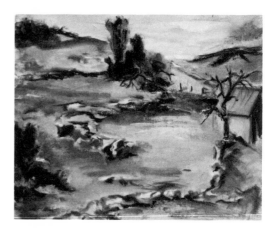

Country Landscape with Old Shed / 1953

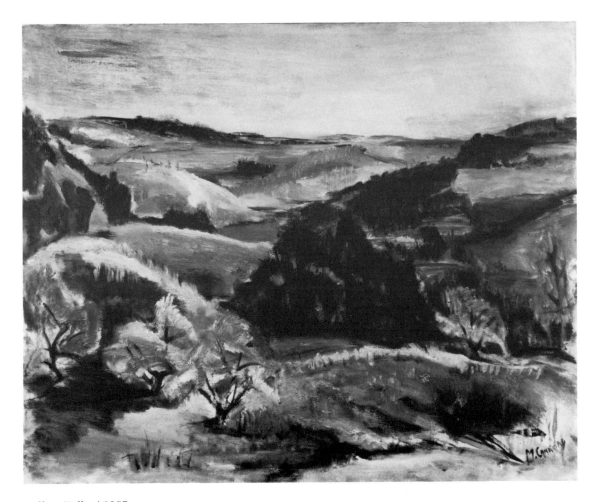

Lefferts Valley / 1957

99 / *The Floch Period*

Slowly, then, she proved to herself, in this period of her work, that abstraction is not an aim in itself but an instrument in the service of beauty and of all that an artist wishes to convey of sentiment or joy in his painting; and here Molly had arrived at concurrence with the pronouncements of Delacroix and Renoir, and other renowned artists, who in their maturity all said, in effect, that a good painter must count his success primarily in creating a feast for the eye and food for the spirit.

So I am proud to have the privilege of offering an introduction to an exhibition which I can so unreservedly pronounce the achievement of a highly gifted artist. I feel, also, that the general culture and great taste so evident in her work here exhibited, were personified in Molly's whole way of life.

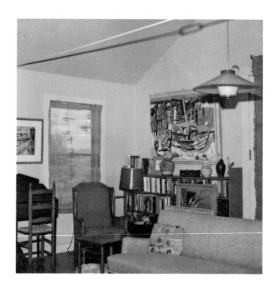

Even when forms were simplified or abstracted these were still factual paintings. They became freer and more intense in feeling as she was more exposed to the work of European abstract expressionists, and the indigenous strange poetry of Morris Graves, the written vitality of Tovey's city paintings. Each year she returned to winter in New York, to the excitement of changing exhibitions, to concerts and theatre and Isamu Noguchi's stage sets, to the lavish explosive talent of Jackson Pollock, to one-man exhibitions of Baziotes and Rothko, de Kooning, and Clifford Still.

She took the Evergreen Review *and had marked an interview, in 1958, with Franz Kline. He said there "the response in the person's mind to that mysterious thing that has happened has nothing to do with who did it first . . . If you're a painter, you're not alone. There's no way to be alone. You think and you care and you're with all the people who care . . . You paint the way you have to in order to GIVE, that's life itself, and someone will look and say it is the product of knowing, but it has nothing to do with knowing, it has to do with giving."*

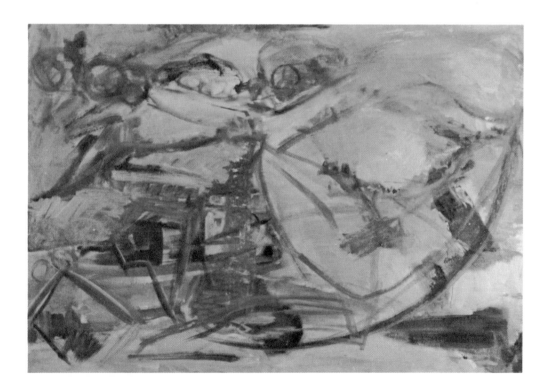

Vermont Landscape Rhythms

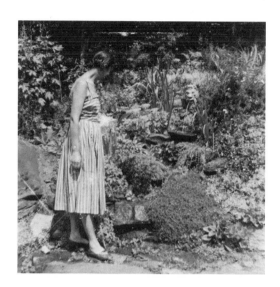

Resolution of the Bent Tree Experience

The year 1959 was one of dramatic importance to me in my concept of Molly's progress, even though it may have been only belated recognition of evolving development throughout her American years.

Belated as these perceptions in the late fifties may have been, they stand out in retrospect for their first really thorough interpretation of Molly's success in weaving the fabric of her life in America from her domestic duties, social engagements, and art applications. My concept, particularly in 1959, may have explained in a major degree a continuing development of her skill in that weaving of her human relationships.

From Molly's earliest years in Toledo, I had noted her ready use of anyone employed by us as a model for first attempts at figure sketches and some figure paintings in colour apart from classroom guidance. In preceding pages I have also remarked upon the execution of a full length portrait that appeared from Molly's brush sometime during each of my mother's annual visits with us. My account of our life reveals her use of visiting relatives and friends as models for sketches or paintings which became eventually a source of special interest to me. However, I was then accrediting each such occasion merely as evidence of an alert use of time and ever-growing dedication to her work as an artist, certainly in 1959, if not earlier. I felt also that it represented her recognition of a need of greater independence in such matters in Toledo than she had felt under family obligations at home in New Zealand.

It never occurred to me until 1955 that there might be deeper significance in this practice than I had observed. It seemed probable that in her new surroundings she was finally and successfully avoiding the frustrations to creative effort she had always experienced during her early home life with its countless relatives and friends.

All those discouraging years of interminable social obligations and diversions she had suffered in New Zealand, one may assume, were gradually being used reflectively to construct consciously and consistently a defensive mechanism which was to prove of great value in thwarting a corresponding threat in America. One uncertainty that troubled me for a time in accepting this surmise was her obviously

genuine fondness for her relatives, both of her parents' generation and her own. Repeatedly she dwelt on individual uncles and aunts, cousins, nieces, nephews, as well as their friends. This seemed to me convincing evidence that her deep sense of family obligation had forestalled development and growth of her latent creative interests and talent in art.

This problem, which had seemed insoluable to her in New Zealand but so soon solved in America, was not explained solely by an independence of family obligation in her new environment. It was evident that she had become as fond of most of my relatives and friends as she had been of her own in New Zealand and that she savored their company too.

In the end, and only very recently, I have come to realize that the explanation lay in the differences of her own condition in the two situations. In New Zealand she had felt only the rather vague innate urge toward creative art without yet having proceeded far enough into development of the techniques for its expression. In America, however, she quickly acquired ability in figure sketching and figure painting, and realized that she could apply this newly discovered skill to artistic practice without any diminishing enjoyment of the companionship of her guests.

With this rationalization, I have become even more firmly convinced that my interpretation of Molly's "bent tree" experience during her New Zealand youth was definitely related to her later success in fitting an art career into our complex life in America.

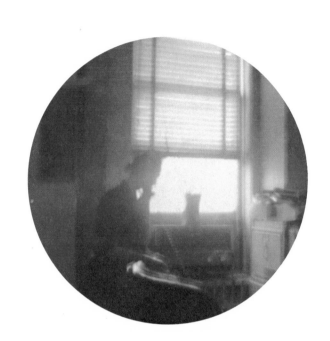

5

Maturity

BY THE YEAR 1960 we had success-
fully sorted out the bounty of New
York's cultural offerings. Our days
were no longer stretched tight as they had
been during our first years in Manhattan
when we attempted to attend a multitude of
public events and private social functions.
Had we not finally learned to do this, fren-
zied activity would have absorbed Molly's
working hours and deprived her of many
quiet evenings at home, so important to
ensuring that she would have energy for
the days of accomplishment ahead.

Through our unceasing cultivation of
the principle of selection we heard practi-
cally every type of musical offering during
the spring, fall, and winter months. We at-
tended performances of the ballet troupes
we found most worthwhile, visited leading
museums which exhibited the best of past
art in permanent collections and passing
shows, attended theaters where we found
those plays most likely to be rewarding, and
kept a constant watch for any commercial
galleries which could be counted on to dis-
play representative contemporary work.
This became the pattern during most of the
1960s, our New York life annually being
interrupted by the summer months spent
in our Vermont retreat at Cleftwaters.

Although Molly had demonstrated no tal-
ent for music during her childhood, she
deeply enjoyed the works of a number of
composers and had cherished a small an-

tique clavichord I had bought her when we
lived in Toledo. After our move to New
York we met Howard Silverer who had
given up a university teaching position to
become a free-lance teacher. During the
early 1960s we arranged with him to come
to us every Thursday morning at ten to give
us two hours instruction, Molly on her
clavichord and later both of us on record-
ers. He carefully planned Molly's weekly
practice assignments to suit both her capac-
ity and limited time. Although neither of us
became very proficient on our instruments,
we nevertheless continued our lessons and
practice into 1970 when Molly's health pre-
vented her from going on with her study.

Insofar as Molly's work was concerned,
she engaged space in a downtown studio
which she shared with Mariann Clubb, a
fellow painter, and sometimes with a third
woman painter. Molly then established a
plan for devoting long daylight hours to
working at her easel in this studio where she
could be found almost daily from 1960
until illness beset her.

This studio not only encouraged her
work but it also provided an additional
plausible explanation for her diminishing
attendance at Joseph Floch's studio. She
hoped that this gradual withdrawal from
the former close association with him would
enable her to make a better analysis and
broader comparison of the work of con-
temporary painters — from conservative to

extremist — which she felt could only be accomplished through an independent survey of their varied styles.

Joseph Floch Looks Back

The break from Floch was eventually accomplished but Molly never ceased to give credit to his guidance in the main principles governing professional painting. It was this, she acknowledged, that had provided her chief training in advanced techniques and enabled her to carry her own spirit and ideas into her painting. Joseph always maintained that he sought to accomplish such tutelage without imposing his own style upon others. However, after more than a full decade of his influence, half of it spent regularly visiting and working in his studio, Molly had at last welcomed her withdrawal from this continuous personal association and criticism of her work.

During the earlier years of Joseph's closer professional association with Molly he did not discuss in any detail the specific guidance she was receiving from his own long European art experience and current work. When I recently took occasion to query him about this, he said,

I have a general recollection of our conversational topics and opinions expressed. It is too far past for me to recall in detail anything of the many discussions we had over her work and mine or the paintings of past and present that we viewed together in the museums and commercial art galleries.

However, he did disclose in general terms the content of his efforts to convey

The Canaday apartment in Central Park was a far cry from the "cold-water flats below 34th street" where "the fate of American art is being decided." She read these and other dicta of Clement Greenberg and followed the criticisms of Harold Rosenberg and looked at the work they interpreted or commended and gradually moved in her own work to reflect the lyrical freedom of the abstract painters, the larger scale and something of the colour construction, of the push and pull tensions, the "inherent laws of the surface" which Hans Hoffman preached in his school and practised in his own "resplendent outbursts" of colour. She may have attended lectures by Hoffman; catalogues from his exhibitions were in her studio.

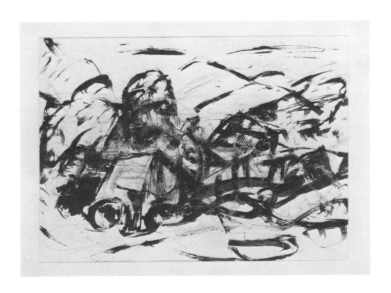

Four drawings representative of Molly Canaday's work in black and white during the sixties.

Spherical Shapes / 1963

his understanding of the principles of artistic creation which he recalled as having been concerned with urging Molly to acquaint herself with the many variations in the uses of *underpainting* in developing harmony.

I impressed upon her constantly the importance of retaining her belief in looking through her own eyes and avoiding imitation. Primarily I sought to impress upon her at all times the great possibilities of expression through color.

I asked him further if he remembered any initial or distinct ideas they might have formed together on issues represented by such terms as "plastic form." This and other such expressions he termed "slogans."

They are mostly a vulgarization or commercial interpretation of an originally interesting thought. Our decade was filled with such slogans. I doubted and still doubt that anything fruitful has come or could come of them and I assume that I mentioned to Molly my skepticism concerning approaches based on such slogans.

He volunteered further,

I always, from the first, encouraged Molly to develop more and more her drawing but I always realized that her main strength is color. She herself was quite aware of this fact. She told me that when she turned to abstract art, the approach to color which she had developed when working with me was of fundamental importance in any elements of her adaptation as in all her earlier work.
We have in our bedroom the painting by Molly that you gave us. The years have preserved and have not changed the finesse of the colors and the keen sense of composition and taste that was hers. We both love it and look at it and study it lovingly at all times.

Study in Abstract Shapes / 1963

Triumph in Color / 108

In a way her work in the last decade of her life suggests that she suffered from over-exposure. Hard enough for the young artist to find his own track, even more difficult for the older and less certain to preserve meaning when the pulls were so vigorous and often so apparently opposed. How to believe in her own small sensation in front of the mystic assurance of Kline's black and white gestures and Hoffman's brilliant slabs of yellow and red? How to remain oneself and yet remain open to disruptive experience?

Prior to 1960 the Canadays had revisited New Zealand and Europe. The tourist impressions she painted of the now-unfamiliar forms of her native land were slight. In the paintings of the Sixties Molly Canaday is learning to understand the problems and responding to the fashions of the previous decade. She increases the size of her canvases, she tries different styles and different paint surfaces.

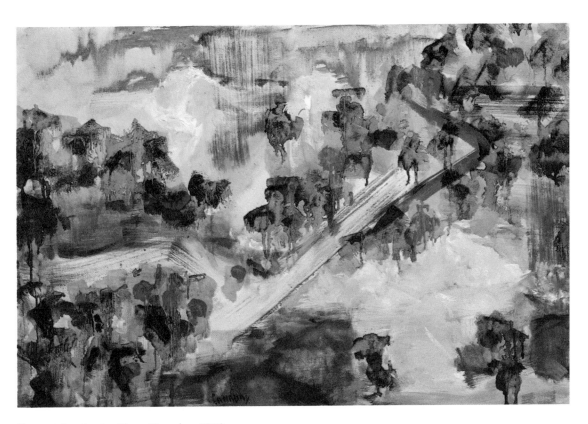

Vermont Landscape, Many Trees / ca 1958

WITH THE artistic independence achieved by working in her own studio, Molly's paintings were still as varied in approach as during the preceding five years of exploration, but they appeared to convey an increased measure of self-guidance. She continued to search for the best way of combining selective contemporary approaches with the basic principles drawn from classical influences. Her wider independent review of contemporary exhibits made a positive contribution but she avoided extremes in developing the style she sought for her own ultimate self-expression.

The discriminating introduction of some of the spirit of abstraction into her work did not diminish her interest in giving equal consideration and prominence to plant life (especially flowers) and people in her composition. At least there was the presence of each, even if in some paintings the human figure became that of a mere foreground observer of the floral element which functioned primarily as background adding spatial depth to the painting.

By early 1963 Molly's paintings included a number that seemed to share a consistency of style that might prove at last to be pointing more definitely toward those directions she would feel content to consider her own.

There was a fantasy scene in which she had experimented quite successfully in the composition of a figure assemblage around some historic event, obviously inspired by paintings she had seen on museum visits. It was evidently a mere passing test of her ability, a painting she was never to do again.

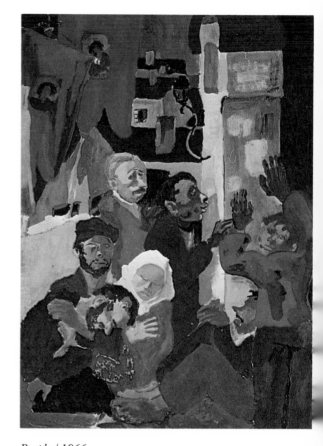

People / 1966

Abstract Symphony / 1958

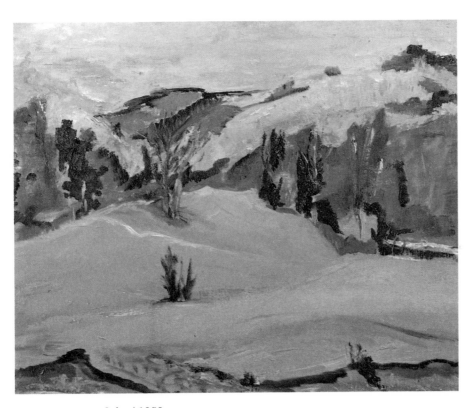

Vermont Autumn Color / 1959

Baroque Figures / 1960

Along with this was a creditable addition to her realistic landscape representations assembled from her summer sketches in Vermont.

Apart from these, other varieties of works seen on excursions amongst the city's commercial galleries could still suggest new experimental canvases that might make a contribution to her own best self-expression. A renewed review, too, of some paintings on permanent or passing exhibit in a gallery might be the originating spark of some idea for a painting of her own.

However, in larger numbers among the canvases she had recently produced were studies of land, sea, and sky, or still lifes in interiors incorporating elements of abstraction such as could have been suggested only in contemporary work. To these she regularly had given a certain individual touch of character that one felt must be distinctly her own.

The Rice Farm, Aerial View / 1962

Sacred Cave with Wisteria, 1962 is the first of her paintings which might be termed abstract expressionist. The dribbles and stains of thin paint are not unlike the contemporary work of an English painter, Patrick Heren. Her work shows that she also learned a great deal from de Kooning, particularly from his landscape – like abstractions which she saw first in the Janis Gallery in 1956.
Rice Farm, *an aerial view of Vermont landscape, is woven with loose linear strokes and scribbled areas of light paint. The last in this manner,* Sea Realm Vista *(1968), is a fine painting. Like the pianist she was, she tries out different paint compositions – from Morris Louis stripes to Dubuffet's textures. The experiments were serious; the influences almost too strong and too diverse.*

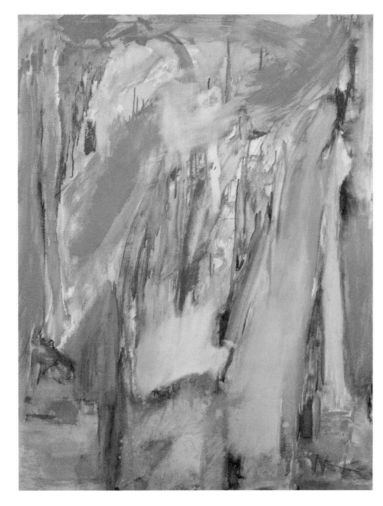

Sacred Cave with Wisteria / 1962

Development of Flower Painting

The subject upon which one early 1963 show was based would have attracted Molly's attendance had it not been ninety miles away at the Philadelphia Museum where there was a comprehensive array of paintings of mixed flowers from five centuries. This had been assembled in the museum's worldwide effort to provide decoration of fitting distinction for the walls of its Greek Revival Temple.

An art magazine *(Art News,* May, 1963) of this period, among the several found in a drawer of Molly's studio, gave a special emphasis to this show in an article with extensive illustrative reproductions. Superb amongst the full color reproductions was one painted by Picasso in 1901 showing a group of chrysanthemums, some of an intense red amongst others of an engaging line of pale yellow, in a green vase. An adjacent reproduction had as its subject a charming gathering of tulips, iris, and a dozen other garden flowers, titled *Bouquet by Window,* done by Ambrosius Bossehaert the Elder in 1619. One black and white reproduction of a mid-twentieth century painting showed a bowl of flowers by Nicholas de Stael, a painter highly regarded by Molly. One was of a realistic garden patch, *Quaker Ladies,* by the currently admired Andrew Wyeth.

Trees in a Vermont Vale / 1966

Clefwaters / 1965

*One sees her struggling with Hans Hoffman's dictum,
"everything you do must be integrated – tension created
between colours and shapes" in a number of works and,
particularly, in rectangular composition a big canvas
in which she tries to reconcile the tension of large areas
of bright yellow, orange, and blue.*

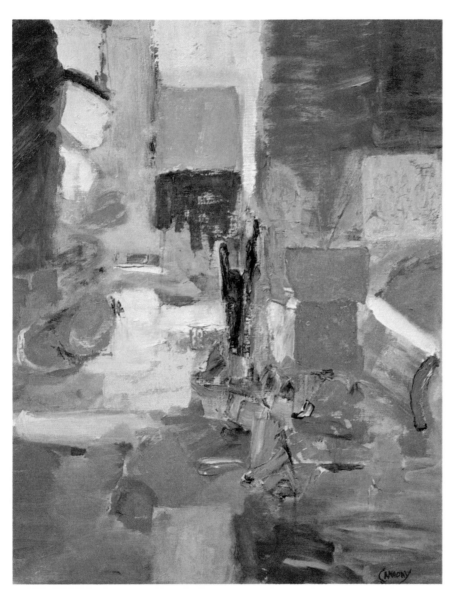

Rectangular Promenade / 1965

In a commentary by Henry Clifford was an especially interesting statement that "when a German painter in Westphalia, Ludger tom Ring, painted a pot of mixed flowers in 1563, he made history!" Clifford proceeded in an elucidation that Molly would certainly have welcomed as technical background complementing her lifelong attraction to flowers and her so frequent inclusion of them in her paintings. It was revealed that the early Italian painters often included flowers in their pictures but rarely warmed wholeheartedly to the subject . . . that the Dutch and Flemish painters appreciated them more because in their northern climate flowers were "harder to grow." Their devotion to still life and depiction of homely objects also made the addition of flowers a high note in such works. This type of painting began with Jan Brueghel and Jacob Vesmaer during the seventeenth century.

In the eighteenth century some excellent work was produced in France and Italy, whereas in the nineteenth century (Delacroix, Doré, Boudin) flowers were rarely the painter's theme. With Impressionism Manet, Monet, and Renoir in particular, brought flower painting again into its own. Fantin-Latour and Odilon Redon became the most prolific in the field, followed by the two giants, Van Gogh and Gauguin, and increasingly Cézanne. Others mentioned as considered contributors of note are Matisse, Rouault, Chagall, and in the United States, Demuth and Georgia O'Keeffe.

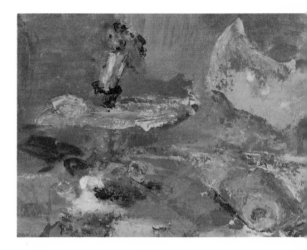

Still Life, Orange Series / 1966

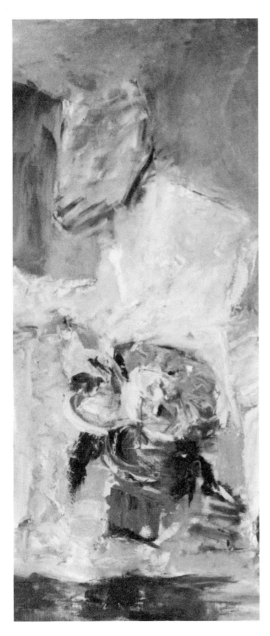

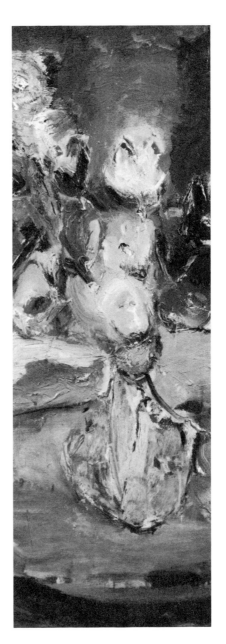

Golden Inspiration / 1965 (detail)

Still Life, Flowers on Green Table / 1967

Accompanying the "Floreat Philadelphia" presentation in this magazine retained by Molly was also an informative illustrated article on Gottlieb as a progenitor of the New York School of painting, credited with a crucial and uncompromising role in challenging the prevailing notion of what painting should be.

Though Molly sometimes painted a bouquet alone, her paintings of flowers were usually associated with a human figure and/or related to an interior setting of some human association.

She early became aware that any painting of flowers required experienced variations in use of the brush along with color and line when arranging the flowers before starting the painting. All these factors went into her sustained success in conveying with paint on canvas the flowers' lovely transient messages coming directly to every viewer of flowers in a garden or vase.

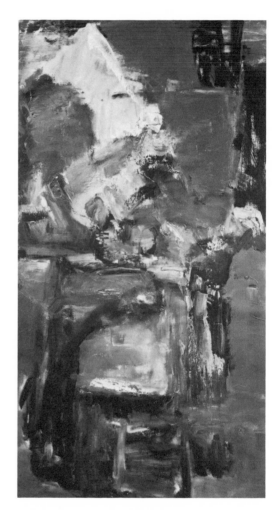

Interior Color Structure / 1963 (detail)

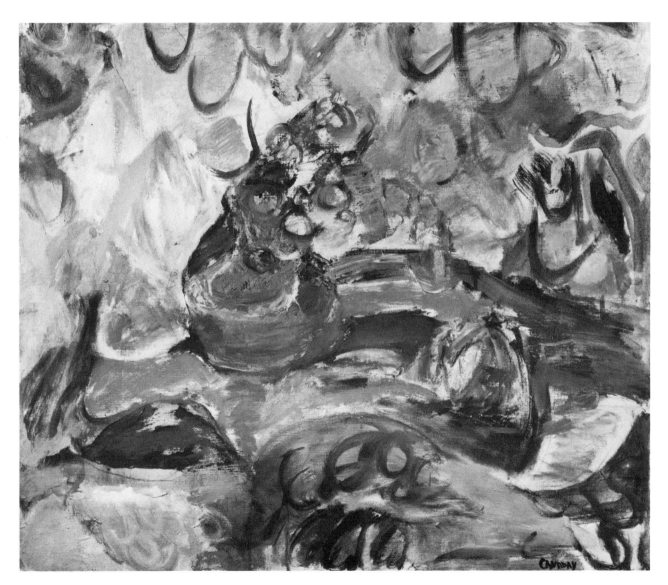

Vivid Still Life in Interior / 1963

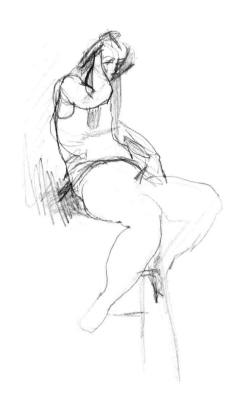

REMAINING in Vermont into October of 1963, again she sought to paint its autumn color drama but the results were not yet satisfying. Nevertheless, she was as in years before, ever nearer to the solution which was to come eventually. Such solution, she now began to realize, required first a retreat from any encompassment of the entire landscape and avoidance of any attempt to reproduce realistically any complex area. She was soon to achieve success with the use of a few simple deciduous trees, each representing one of autumn's chief colors — red, yellow, orange — with accents of green from one or two of the interspersed evergreens.

In canvases inspired by her sketches of Vermont during the earlier months of the season, however, she continued to advance more skillfully in conveying the typical elements of streams, trees, and hills, with an interweaving of the lines of Vermont's flowing meadows. For some such painting done in 1963 and in the years immediately following, a number of tentative preparatory sketches of compositional intentions were made in her Cleftwaters studio for use in New York and have been recognizable in sketchbooks left by her. Some of these bore color swatches to serve as intended color guides as she sought authentic representation of the Vermont colors.

To return to additional mention of Molly's own New York program during this decade of the 1960s, one of the activities she included almost every weekend was attendance at a lengthy Saturday life class in the Art Students' League building on 57th Street. Her retention of so much of what

Colony on the Dunes / 1965-66

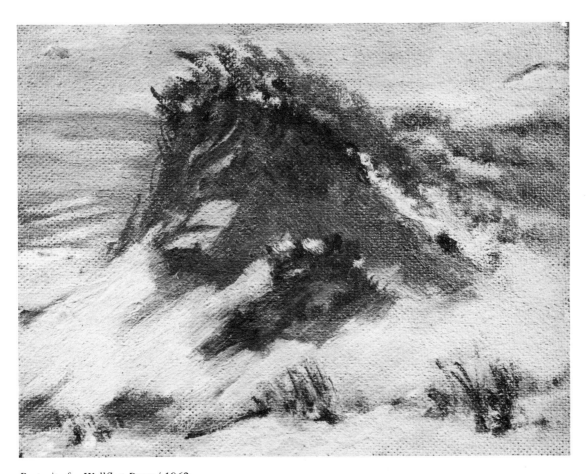

Portrait of a Wellfleet Dune / 1962

she had learned from various sources about figure drawing and figure painting was undoubtedly due to this habitual exercise.

Meanwhile Molly was producing some mature figure paintings which gave forth character, creating a more searching emotional impact through her handling of posture and setting, and suggesting the subject's personal situation and probable mental perspective.

In many of these paintings she was making regular use of the models Floch employed to pose in his studio. In one such work the model served as the basis of a figure projected against an array of contrasting colors in a background representative of cushions on a couch cover. There a girl of seeming late teens or early twenties was shown seated, one leg comfortably across the other as if contemplatively awaiting some person or event, a projection not of personality alone, but of a personage, offering the added interest of being in a suggested "situation." The situation, not defined, invites speculative participation on the part of each beholder. This, along with the projection of a real personality in a background of pleasing colors, produces a painting of broad human interest.

Subsequently she undertook another series of paintings of a very different style based on assemblages of bottles of varying shapes and colors. One of these won first prize for painting at the annual New York show of the National Association of Women Artists.

Fantasy Landscape / 1964

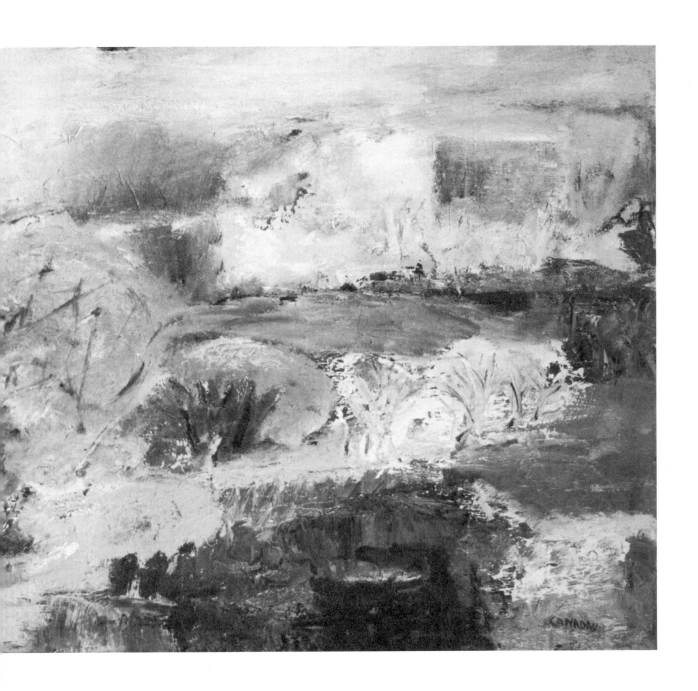

123 / *Maturity*

Battle of the Bottles

It is a classic of art history that painters of almost every age, at some period have been intrigued to deal with bottles—their varied shapes, nuances of colors, their challenges of transmuted and reflected light, their endless possibilities of arrangement — each with its new demands on the artist's technique in the rendering of texture, form, and color harmony in the complexities of a kaleidoscopic environment. Out of a series of patient concentration on a subject seemingly inert and of minor interest to the layman's eye, the descent of a kind of sudden glorification upon some reassemblage of commonplace forms may reward the knowing persistence of the artist.

Interesting enough were Molly's color drills of these "dead soldiers," one done abstractly in a still life color medley with a bowl and fruit. In first one arrangement, then another, she put them in a ragged assembly line, her experiments with these seemingly hopeless recruits, untidy at initial inspection, became a bit more interesting in later tactical formations. Finally, after further contemplation and rumination in winter quarters, in a changed assembly on a new field of parade—new in colors, tonality, and intention — the painting metamorphosed suddenly into a "combat unit," quietly self-confident, which went forth in such mature painted quality that, as mentioned above, judge and jury of the National Association of Women Artists immediately recognized it as deserving a top award.

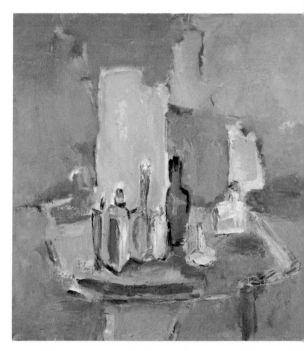

Bottle Series / 1966

From 1965 to 1968 she sets up for herself her own problems in five large canvases, Bottles I to V — *rectangular slabs of colour, juicier paint. In* Convocation *(1966) and* Homage to De Stael *(1968) she expresses both her debt and her independence. Yet through this last decade of her life with its frenzied work and huge output, with its numerous lines of experiment, there are, each year, paintings which are the reflection of no temperament but her own, the cumulation of her life's philosophy and sensitivity.*

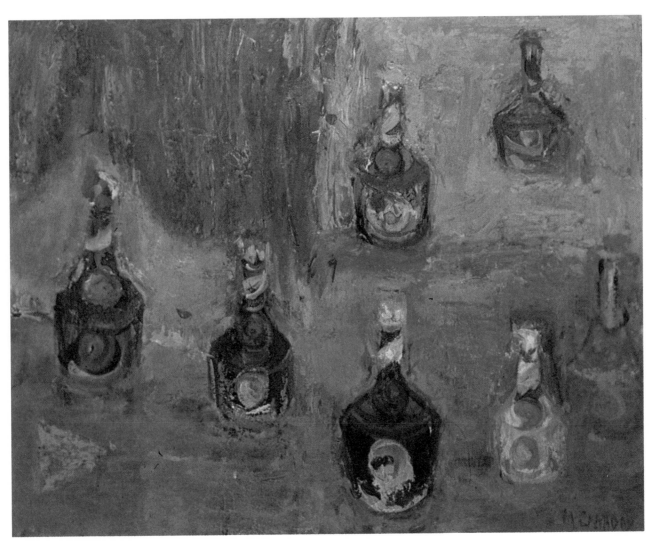

Bottles on Red Ground

Another done midway in the series presented the bottles in glass greens, glass browns, and yellows, also one of plain uncolored glass, a transparency against background panels in tawny yellows, red-orange, and lavender. This colorful canvas proved so alluring to one friend's sophisticated eye that I allowed her to purchase it by making payment with a contribution to the scholarship fund of Toledo's Art Interest, Inc.

Still another such painting of the mid-series, showing the bottles in a range of more pallid orange and green and a color-tinted gray with abstracted background areas, had a compositional and tonal quality with an effect for me of reducing the inert bottle shapes into a seeming assembly of reverential religious worshippers. The National Association chose it as one of forty paintings carefully selected to go as a traveling collection sponsored by the Association for exhibition from July, 1967, through April, 1969, in museums, universities, and important art centers throughout the United States. It was one of the five reproduced in black and white to embellish the Association's brochure introducing the traveling collection, which also included under Molly's name a brief biography of her art life.

City Phantasy, Moon Over New York / ca 1966

Pilgrimage by the Sea / 1968

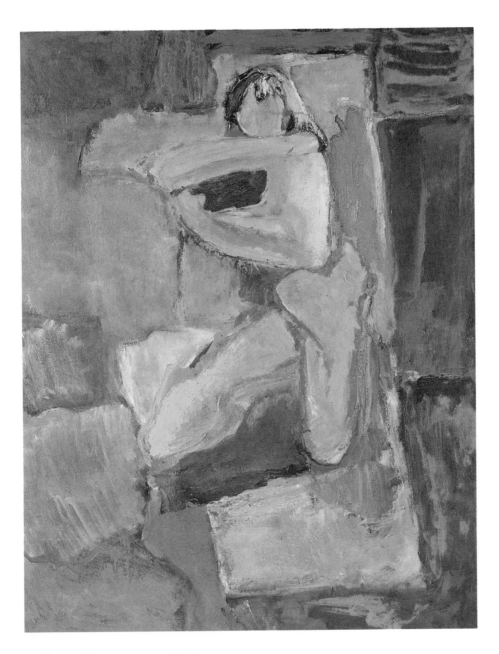

Half-seated Nude in Interior / 1966

Vermont Trees in Autumn / 1965

*She had always liked Chinese paintings and
calligraphy. This subtle influence is expressed in the*
Moon and Planet *series, in her views of New York,
in her original* Moon Over New York *and* Deep
City Landscape; *in the poetry of* Beach with Birds.
*Her feeling for the Vermont landscape is best expressed
in the more abstract handling of these last paintings:*
Orchard Trees, Vermont, Trees in Autumn,
Meadow Landscape *and the haunting image,* Pale
Sun Over Vermont.

Autumn Glory / 1965

Beach with Birds / 1968

DURING that same year Molly received an invitation from New Zealand Ambassador Laking to participate in the official project in Washington whereby available art works of her country's nationals were to be displayed in the embassy. Having produced art of increasing note over more than thirty years of residence in America, Molly was the artist most represented in the show, fourteen of her paintings being on exhibit. Some of the titles indicate the character of paintings selected: *Wellington Harbour, Maori Chief, The Green Table, Blue Table, Vermont Landscape, Colour Composition, Gardenia 11, Orange Fantasy, Bouquet Against Greenery, Sea of Tranquility, The Bottles,* and *Ballerina.*

Growing Interest in Abstraction

Apart from any concentration upon a development of particular subject matter, there came forth at intervals paintings such as an untitled one to which I gave the identification, *Abstract Distraction.* This had basic landscape motifs represented by soft-edge horizontal color swatches, green above a foreground base of red-brown, with a rich gray for sky above. I could have thought of it as representing a memory of Australia's vast areas of "Never-never" land which Molly may have seen from a plane, but during this year (1966) it had its origin, more probably, from some of the summer wandering we had done in the deserted inland regions of dwarfed trees and brush on Cape Cod.

Girl Dancer / 1965

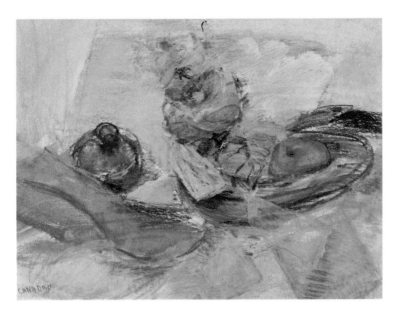

Still Life, Fruit and Flowers / 1966

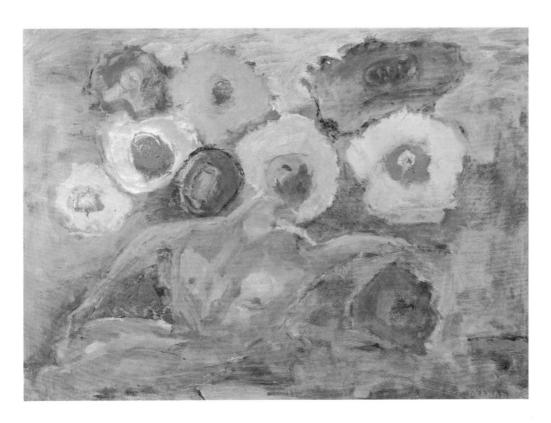

Gay Girl with Flowers / 1964

Trees in a Field / 1966

In another canvas there was greater attainment of structural form, holding forth similar token impressions. It had achieved satisfactory space allocations and harmony with very subdued color, presenting a concept of a city at dusk. Perhaps it was assembled from impressions registered on those occasions when Molly and her studio mate Mariann had stayed late to finish some phase of their work. Often, before departing, they paused to sit over a restorative sherry or cup of coffee, looking through dusty windows while they probably carried on philosophical discussions about the mystery of life or of art in life.

A more orthodox employment of definite abstract forms was evident in a few other paintings completed during the year's last quarter. These had likely come forward from memories captured by Molly's mind as it retained certain impressions which were acceptable to her taste during her wanderings into the realm of the self-styled "avant garde." As Floch said of her then, and more than once, "She understands that abstraction is not an end in itself; that it is just another instrument in the service of beauty . . . and of all that an artist may wish to convey of himself in his painting . . . maybe, as well, of his sentiment or joy in its making."

Reclining Nude / 1969-70

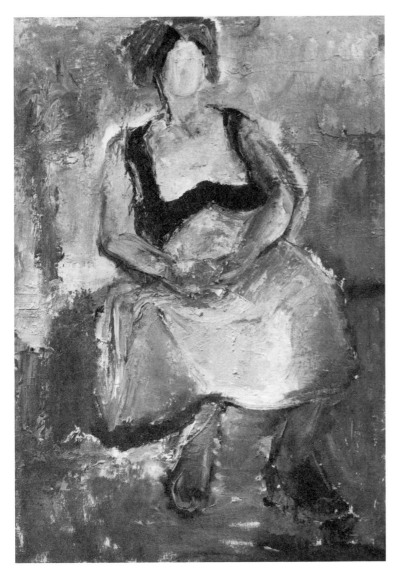

Posed Seated Figure / 1967

Seated Woman / 1969

WHEN we returned from Vermont in the fall of 1967 Molly's studio mates were so impressed with the amount and quality of the work she had produced that summer that they persuaded her to contact some of the galleries to seek a new outlet for her paintings. In most cases she was courteously received but the replies were either "Telephone for an appointment" or "Not today, but call again."

One gallery which regularly exhibited works of such well known artists as Milton Avery, Theodore Fried, Karl Knaths, and Sigmund Menkes, expressed some interest in her work but apparently not enough to encourage her to return to see them again. In another gallery where she was permitted to show her work, it brought forth the comment that it was "bright realism that might have a place among the paintings producing sales so occasionally that they don't count." This persuaded her that such efforts were a waste of painting time and she abandoned her brief effort.

Molly's Last Trip Home

Since mid-1966 Molly's sister Nona had been urging that Molly visit New Zealand. By the following autumn the gradual decline in her health convinced me that I should persuade her to make an overdue trip to her homeland. In fact, although I hardly admitted it to myself, I felt that such a visit to her family should be arranged immediately while she still had the energy to undertake the journey and enjoy the summertime-Christmas holidays in Wellington.

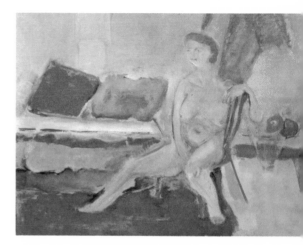

Feminine Situation / 1967

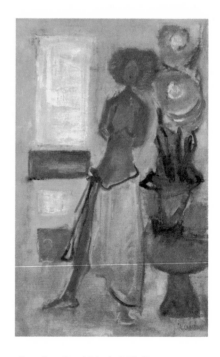

Amusing Semi-Nude / 1967

The final strand over these years gives entirely her own view, in slightly wry, amused paintings of women; here the gawdy Girl Dancer *the* "Amusing" Semi-Nude, *the ironic* Feminine Situation, *the decorative* Gay Girl with Flowers *and the moving final painting,* Young Mother and Daughter *are complete expressions of her temperament and her technical mastery. This is the life, in paint of a responsive, sensitive, modest and lively woman.*

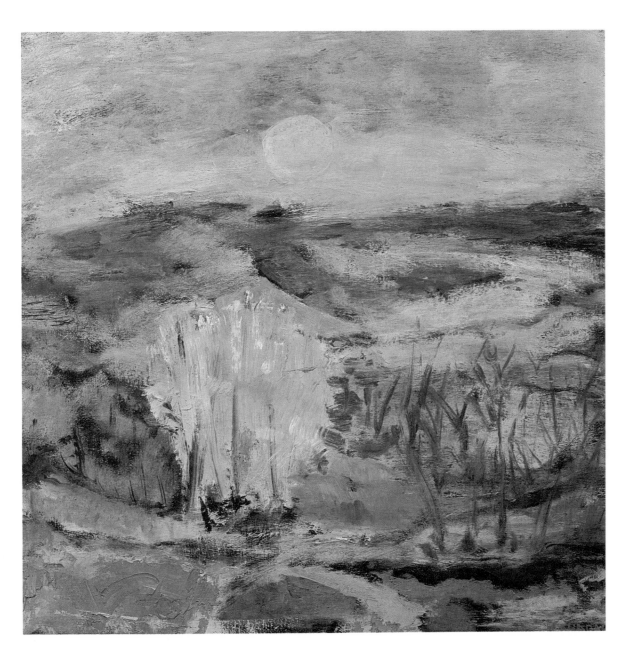

Pale Sun Over Vermont / 1967

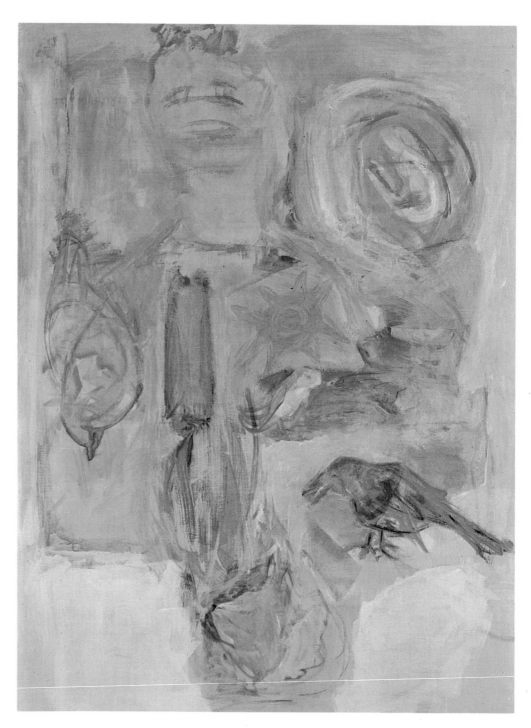

Big Flowers and Bird / 1967-68

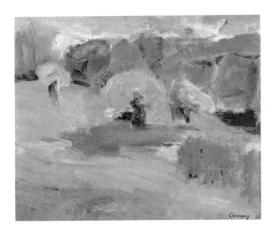

Rice Farm / 1967

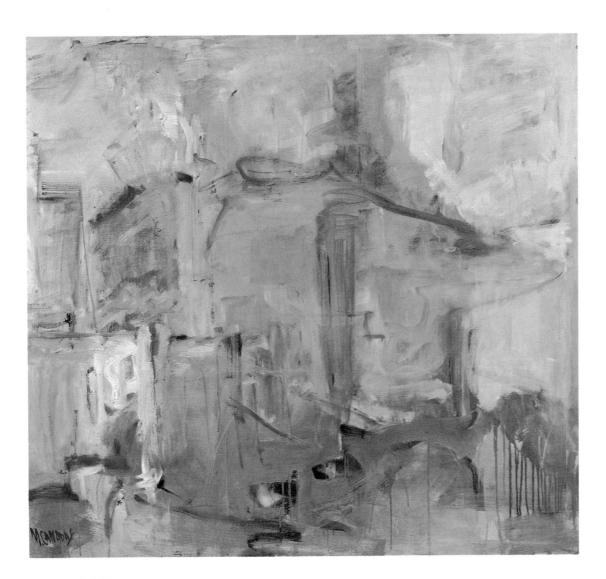

Deep City / 1968

So it came about that we started in October to make plans and include in our trip the satisfaction of a mutual desire to see something of Mexico. We ruled out Mexico City, the doctors having told us that Molly's heart condition required that she keep her travels within an elevation of five thousand feet above sea level. However, we included a tour of the lowlands of Yucatan to enjoy the ancient Mayan culture and a visit with friends in Oaxaca, at an exact five thousand foot elevation. Our journey then continued on from Acapulco with brief stops in Hawaii and Fiji to arrive in New Zealand in time for the Christmas holidays.

Molly greatly enjoyed returning to the familiar family festivities, revisiting the old country place in the Hutt River valley, and making various short trips about New Zealand. A ten-day rest in a delightful cottage with a view of the sea so restored Molly's sense of well-being that she favored continuing as planned on a homeward route that would take us to places we both had long desired to know: Singapore, Bombay, Beirut, Istanbul, Cairo, and Lisbon. Molly's strength and spirits held up well throughout each lengthy leg of the journey and continued through the final flight which returned us to New York.

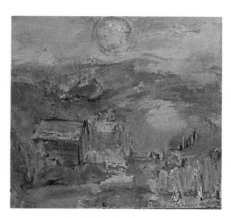

Pale Sun Over Vermont II / 1967

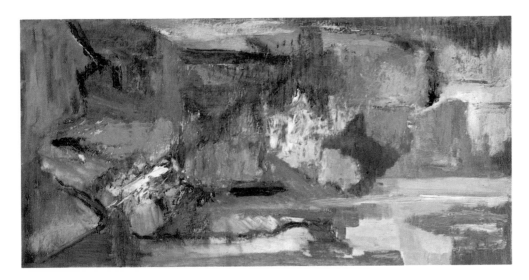

Street Medley, New York / 1968

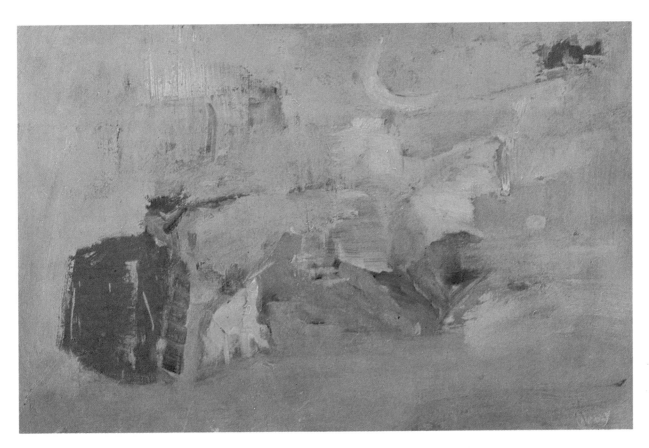

Moon Over New York / 1966

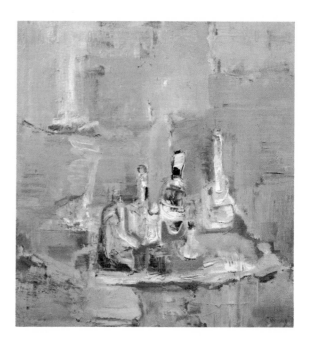

The Bottles / 1966

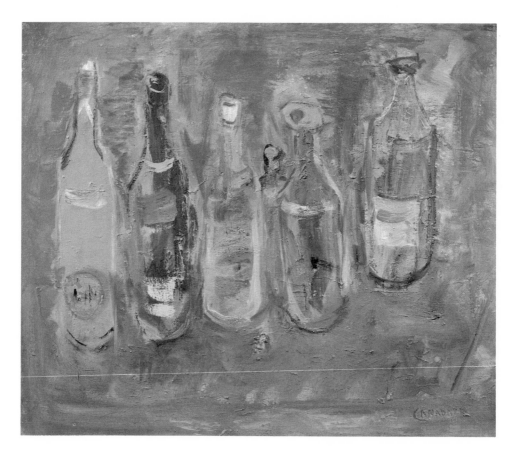

Bottles II /1965-66

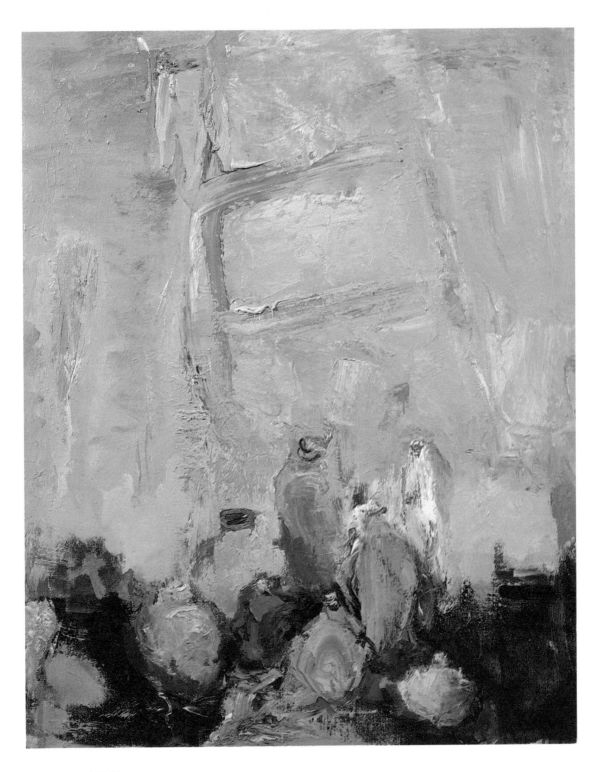

Convocation / 1966

ON OUR return to New York Molly's doctor imposed a definite rule that in her long climb to her studio she must mount the steps a few at a time, and rest by sitting on a cushion which she always carried with her. Without conveying to her any exaggerated alarm, he made us both aware that her heart condition demanded restraints to a greater degree than had been required earlier. In spite of such handicaps this was the year of perhaps her greatest accomplishment wherein she produced quantities of her life's finest work. It seemed appropriate as we look back upon it to have 1968 end with a small two letter word "on." From this cryptic syllable she would have declared undoubtedly with regard to the years ahead:

On with better painting . . . better in color . . . better in color harmony . . . better organized in its composition . . . firmer in more skillfully woven and confident brush stroke . . . greater in impact and intensity of beauty . . . no expectation of masterpieces . . . simply 'on' to such better paintings as my attainments as an artist might produce.

Such resolve was destined to be short-lived, however. During the next two years as Molly's strength ebbed, the visits to the studio became less and less frequent, the painting gradually tapered off, and the work halted during 1970. To the end her quiet patience and forebearance heroically masked the suffering and ever increasing weakness. Finally, in January of 1971, there was release for her — and grief for me.

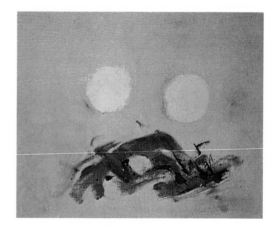

Double Sun Over Earth

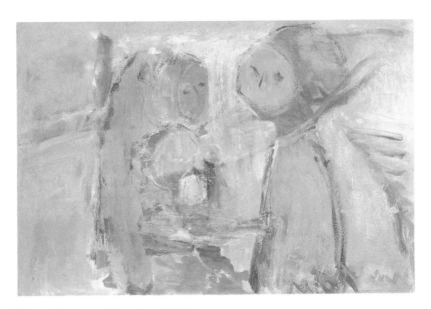

Young Mother and Daughter / 1968

Do not go, my love, without asking my leave.

I have watched all night, and now my eyes are heavy with sleep.

I fear lest I lose you when I am sleeping.

Do not go, my love, without asking my leave.

I start up and stretch my hands to touch you. I ask myself, "Is it a dream?"

Could I but entangle your feet with my heart and hold them fast to my breast!

Do not go, my love, without asking my leave.

The Gardener, *Tagore*

143 / *Maturity*

I T IS DIFFICULT AT BEST to write honestly and definitively of someone known intimately and loved, and retain in the recounting of emotions and fact any measure of objectivity. Yet, this is the task Frank Canaday set for himself at Molly Canaday's death in 1971, a task made infinitely more difficult by rapidly failing health during the last two years of his life. He drove himself unmercifully during this period to put in order a staggering volume of material. Much was the personally important trivia of a long and extraordinary lifetime, but most concerned the essential record of the life and art of a woman of modest talent who, nonetheless, achieved measurable success as painter and colorist.

The message Frank Canaday felt compelled to pass on to others was essentially simple; that modest talent and pursuit of a normal and happy life do not preclude the achievement of serious artistic success, provided sensitivity and a dedication to work are their constant companions. Thus this book became not only a record of the life of Molly Morpeth Canaday, but a record of her work, from her earliest uncertain beginnings to the achievements of her final years.

Regrettably, at Frank Canaday's death in June, 1976, the records of neither were impeccably ordered or wholly complete, and it became the publisher's responsibility to sift the documents and fill the gaps. Despite the unselfish help of Janet Paul, whose art commentary complements the text, Idene H. Ayers, one of Molly's teachers at the Toledo Museum of Art School of Design, and both family and professional associates, uncertainties remain as press time approaches, and it is hoped that, if noted, the reason for their existence will be understood.

Whatever omissions or inaccuracies may exist should not in any way color the story of these two lives, nor distort the visible evolution of Molly Morpeth Canaday's work and achievements as an artist.

The Publishers

Canaan, New Hampshire
November 1, 1976

Appendices

145

Molly Morpeth Canaday

Born Wellington, New Zealand, February 5, 1903. Daughter of Florence Euphemia and Charlton Douglas Morpeth.

Marsden Collegiate School, New Zealand. Studied painting, sculpture, and art history at the Toledo Museum of Art, 1932-41
Also studied with Israel Abramofsky, Toledo, 1937-41; Joseph Floch, New York, 1941-57; Jean de Botton, New York, 1958-59; Sam Adler, Chaim Gross and Madeleine Gepière at New York University and at the Art Students League in New York.

Married Frank H. Canaday, Toledo, December 17, 1932.

One Man Exhibitions

1948	Toledo Museum of Art, Toledo, Ohio
1949	Dudensing Gallery, Woodstock, Vermont
1950	Royal Oak, New Zealand
1952	Women's Club, Stamford, Connecticut
1958	Toledo Museum of Art, Toledo, Ohio

Group Exhibitions

1937-47	Toledo Museum of Art, Area Artists Annuals (periodically)
1950-70	Youngstown, Ohio Annuals
1950	Whitney Museum Benefit Show, New York
1955	Manchester, Vermont Annual
1956	Lynn Cottler Gallery, New York
1956	Cracker Barrel Annual, Northern Vermont
1959-69	National Association of Women Artists Annuals, New York
1963	Imago Gallery, New York
1964-67	Pietranonio Galleries, New York, and Westhampton Beach, Long Island, New York
1964	National Academy of Design Annual
1965	Springfield, Massachusetts Annual
1965	La Salle University Annual, Philadelphia
1965	U.S. Exhibit, World's Fair, New York
1966	53rd Allied Artists Annual, New York November 3-20

Prizes, Awards, and Honors:

1942	Honorable Mention, Toledo Area Artists Annual, Toledo Museum of Art.
1944	Roulet Medal, Toledo Museum's first prize for oils, Toledo Area Artists Annual.
1964	National Association of Women Artists Annual, New York
1966	Marcia Brady Tucker Prize. A top award for oils in the annual exhibition of the American Association of Women Artists, at the National Academy Galleries, Fifth Avenue, New York.

The prize winning still-life of 1966 titled "Bottles," was chosen to go in the Association's Group Exhibit touring the U.S. for two years, 1967-1968. In February, 1966, Mrs. Canaday was invited by New Zealand Ambassador Laking to exhibit fourteen paintings in the New Zealand Embassy in Washington, D.C., a principal part of an exhibition of works by New Zealand artists. The exhibition was also sponsored by the Corcoran Gallery, Washington, D.C.

1971	The American Association of Women Artists invited Mr. Canaday to enter one of Mrs. Canaday's latest paintings in the 1971 annual exhibit in New York as a tribute to her memory.

Mr. Canaday offered a prize for oils in Mrs. Canaday's name at this 1971 exhibit, and later arranged for this award to be perpetuated as the Molly Morpeth Canaday Memorial Prize for Oils — at each succeeding annual of the American Association of Women Artists.

1972	Retrospective exhibition of paintings from 1935 to 1969 at the Toledo Museum of Art, jointly presented by the Museum, and Art Interests Incorporated, Toledo.
1974	Retrospective exhibition of paintings from 1935 to 1969 at The National Art Gallery of New Zealand.

Urban Landscape / 1933 / Oil on canvas / 18" x 20"
Head of a Woman / 1934 / Oil on canvas / 12" x 9"
Roses in a Teapot / 1934 / Oil / 12" x 16" **37C**
Urban Landscape / 1934 / Oil on canvas / 26" x 16"
Basket of Flowers / 1935 / Oil / 32" x 23"
Old Union Station, Toledo / 1935 / Tempera on cardboard
 28" x 21" **31C**
Girl with White Ribbons / 1936 / Oil on board **35C**
Still Life Teaset / ca 1936 / Oil / 12" x 16"
Ceramics and Fruit / ca 1937 / Oil / 15" x 12"
Maumee Valley Landscape / ca 1937 / Oil on canvas
 16" x 20" **29**
Mother Reading Letters / 1937-38 / Oil on canvas
Interior with Flowers and Fruit / 1938 / Oil on canvas / 30" x 18"
Seated Woman / 1937-38 / Oil on canvas / 20" x 13" **29**
Self-Portrait of Artist at Work / ca 1938 / Oil / 22" x 34" **32**
Urban Landscape, Toledo / 1938 / Oil on canvas / 26" x 16"
Viaduct in Suburb of Toledo / 1938 / Oil **25C**
Woman in Yellow Blouse / 1938 / Oil on board / 20" x 15"
Anemones in Jug / 1939 / **36C**
The Easel / 1939 / Oil on canvas / 29" x 16"
Figure with Flowers / 1939 / Oil on canvas / 34" x 22"
Spring Blossoms / 1939 / Oil 22" x 16½"
Vase of Flowers / ca 1939 / Oil / 19" x 12"
Jug and Apples / 1940 / Oil on canvas / 7" x 8½"
Still Life with Green Vase / 1940 / Oil on canvas / 12" x 16"
Sweet Williams / 1940 / Oil on canvas / 14" x 10"
Woman Arranging Flowers / 1940 / Oil on canvas / 32" x 21"
House on Watova Road / 1941 / Oil on board / 26" x 20"
The Majolica Cheese Dish / 1941-43 / Oil on board / 26" x 20"
Still Life — Vase and Lemons / 1941 / Oil on board
Watova Road House / 1941-43 / Oil on board / 15" x 12"
Blossoming Tree / 1942 / Oil on canvas / 16" x 12"
Country Lane / 1942 **53**
Fruit in Gray Bowl / 1942 / Oil on canvas / 12" x 15" **48C**
Girl with Red Dress, Blue Scarf / 1942
Head of a Girl / 1942-43 / Oil on board / 19" x 12"
Interior, Watova Road — Yellow Armchair / 1942-43
 Oil on board / 16" x 12" **51**
Seated Nude / 1942 / Oil on canvas / 21" x 18" **61**
Seated Woman in Green Blouse / 1942 / 20" x 17½"
Still Life — Bowl and Book / 1942 / Oil on board
Still Life with Green Vase / 1942 / Oil on canvas
Tea on the Terrace / 1942 / Oil on canvas / 21" x 14" **53**
Watova Living Room / 1942 / Oil **49C**
Watova Road / 1942 / Oil on canvas / 18" x 24"
Wellfleet Dune / 1942 / Oil on board / 9" x 12"
Apples and Blue Glass Vase / 1943 / Oil on canvas / 16" x 12"
Blue Bowl and Fruit / 1943 / Oil / 18" x 14" **58C**
Figure Painting / 1943 / Oil on board / 11" x 7½"
Husband at Work / 1943 / Oil on canvas / 24" x 18" **51**
Leaves and Fruit / 1943-44 / Oil on Canvas / 18" x 24" **57**
Man at Desk / 1943 / Oil on canvas / 24" x 18"
Mother Canaday at Molly's Desk / 1943 / Oil on canvas **49C**

Mother Canaday in Watova Garden / 1943 / Oil on canvas
Mother Canaday Reading Letters / 1943 / Oil on canvas
Seated Figure / 1943 / Oil on canvas / 19½" x 17½"
Still Life with Blue Vase / 1943 / Oil on canvas / 14" x 23"
Still Life with Model Ship / 1943 / Oil on canvas
Vigorous Bananas / 1943 / Oil on canvas / 20" x 23" **57**
Figure in Interior / 1944 / Oil on canvas / 26½" x 20" **63**
Head of Alexis Hook / 1944 / Oil on board / 9½" x 7¼"
Leaves in Vase and Fruit / 1944 / Oil on canvas / 14" x 23"
Meditation / 1944 / 25" x 16"
Molly with Bangs / ca 1944 / Black crayon / 20" x 14" **51**
Seated Figure in Brown / 1944 / Oil on canvas
Seated Nude / 1944 / Oil on canvas / 17" x 13"
Seated Nude / 1944 / Oil on canvas / 21" x 18"
Studio Corner / 1944 / Oil on canvas / 29" x 16" **53**
Winter Bouquet / 1944 / Oil on canvas
Woman in Yellow Blouse / 1944 / Oil on canvas / 29" x 16"
Seated Figure / 1945 / Oil on canvas / 26½" x 20" **63**
Still Life with Rose / 1945 / Oil on canvas / 22" x 18"
Two Interiors, Round Table and Green Cloth / 1945
 Oil on board / 24" x 18"
Greenwich Village Rooftops / 1946-47 / Oil **70C**
Kathy's House Next Door / 1946 / Oil on canvas
Alexis and Baby Andrew / 1947 / Oil on board **61**
Figures in Interior / 1947-48 / Oil on canvas / 24" x 18" **65**
Home Musical / 1947 / Oil on canvas / 25" x 20" **65**
Woman Seated in Green Chair / 1947 / Oil on canvas / 16" x 12"
Figures Conferring / 1948 / Oil on canvas / 22" x 18"
Home of Mr. and Mrs. W.D. Canaday / 1948
Nona with Flowers / 1948 / Oil on canvas / 34" x 30"
Rooftop Vistas of Greenwich Village / 1948 / Oil on canvas
 22" x 18"
Seated Woman in Red Skirt / 1948 / Oil on canvas
 18" x 12" **59C**
Still Life with African Mask / 1948 / Oil on canvas / 18" x 28" **70C**
Still Life with Copper Bowl / 1948 / Oil on canvas / 21" x 18"
Alexis with Baby Edith Ann / 1949 / Oil on board / 16" x 12" **88C**
Country Couple / 1949 / Oil on canvas / 41" x 28"
Edith Ann / 1949 / Oil on canvas
Figures and Red Screen / 1949 / Oil on canvas / 38" x 32"
Formal Garden at Upwey / 1949 / Oil on canvas / 30" x 20"
Girl with Cat / 1949 / Oil on canvas / 20" x 15"
Morpeth Sisters / 1949 / Oil on canvas / 22" x 18"
Ohio Landscape / 1949 / Oil on board **67**
Seated Figure in Studio Interior / 1949 / Oil
Seated Figure on Blue Couch / 1949 / Oil on canvas / 18" x 22"
Still Life, Flowers in a Vase / 1949 / Oil on canvas / 32" x 15"
Still Life with Jug and Fruit / 1949 / Oil on canvas / 16" x 20"
Still Life with Mask and Bowl / 1949 / Oil on canvas / 18" x 21"
Summer Cottage / 1949 / Oil on board
Summer Holiday, Stamford / 1949 / Oil on board
Upwey / 1949 / Oil on board / 19¼" x 26¼"
Upwey Pool / 1949 / Oil on board / 12" x 9" **92C**
Violin Still Life / 1949 / Oil on canvas **65**

Sacred Cave with Wisteria / 1962 / Oil on canvas
 50" x 38" **113C**
South Wellfleet Dunes / 1962 / Oil on board / 9" x 12"
Woman Seated in Garden / 1962 / 22" x 16"
Abstract of a Dawn Landscape / 1963 / Oil on canvas / 40" x 32"
City Fantasy — Moon Over New York / 1963 / Oil on canvas
 40" x 26"
Figures in Landscape / 1963 / Oil on canvas / 28" x 22"
Floral Study / 1963 / Oil on paper
Golden Inspiration / ca 1963 / Oil on canvas / 60" x 52"
Interior Color Structure / 1963 / Oil on canvas / 51" x 35" **118**
Seated Woman with Black Gloves / 1963 / 29" x 24"
Spherical Shapes / 1963 / Oil on canvas **108C**
Still Life / 1963 / 24" x 48"
Studio Dream / 1963 / 24" x 18"
Studio Dream Interior / 1963 / Oil on canvas / 51" x 35"
Studio Vista / 1963 / Oil on canvas / 50" x 40"
Study in Abstract Shapes / 1963 / Oil and acrylic
 on canvas **108C**
Vivid Still Life in Interior / 1963 / Oil on canvas **119**
Fantasy Landscape / 1964 / Oil on canvas **122-123**
Field and Farm / 1964 / Oil on canvas
Gay Girl with Flowers / 1964 / Oil on canvas / 36" x 50" **131C**
Imitative Exercise / 1964 / Tempera on board / 20" x 14½"
Interior with Green Plant / 1964 / Oil on canvas / 46" x 26" **2C**
Lavender Shape on Dark Blue "Flames of Creation" / 1964
 Oil and acrylic on canvas / 25" x 30"
Many Large Gay Flowers / 1964 / Oil on canvas / 36" x 50"
Maori Warrior / 1964 / Tempera on canvas / 50" x 36"
Silver Collage / 1964 / Paint and metallic papers
Still Life, Orange Series / 1964 / Tempera on board / 16" x 12"
Studio Assemblage of Abstract Shapes / 1964 / Oil on canvas
Sunday Painter / 1964 / Pen drawing
Sunrise Over Misty Meadows / 1964 / 25" x 28"
Variation in Vermont Landscape / 1964 / Watercolor
Another Studio Abstraction / 1965 / Oil on canvas / 26" x 40"
Autumn Glory / 1965 / Oil on canvas / 30" x 24" **129C**
Blue Bowl with Flowers / 1965 / Oil on canvas / 25" x 30"
Blue Vase with Flowers / 1965 / Oil on canvas / 30" x 20"
Bottles and Fruit / 1965 / Oil on canvas / 40" x 32"
Bottles II / 1965-66 / Oil on canvas **140C**
Cleftwaters / 1965 / Crayon **114**
Colony on the Dunes / 1965-66 / Oil on board / 9" x 12" **120**
Exotic Landscape / 1965 / Oil on board / 18½" x 24"
Farm in Autumn / 1965
Flower and Leaf, Still Life / 1965 / Oil on canvas / 20" x 24"
Girl Dancer / 1965 / Tempera on board / 72" x 18" **130C**
Golden Inspiration / 1965 / Oil on canvas / 60" x 52" **117**
Interior with Green Plant / 1965 / Oil on canvas / 46" x 26"
Landscape / ca 1965 / Oil on board / 18½" x 24"
Landscape / 1965 / Watercolor
Manhattan Terrace / 1965 / 46" x 26"
Meadow Landscape / 1965 / Oil on canvas
Moon and City / ca 1965 / Oil / 34" x 30"

Mt. Ascutney / 1965 / Watercolor
Mt. Ascutney from Hill on Rice Farm / 1965 / Oil on canvas **8C**
Rectangular Promenade / 1965 / Oil on Canvas / 42" x 36" **115C**
Still Life, Flower and Leaf / 1965 / Oil on canvas / 20" x 24"
Still Life, Fruit and Flowers / 1965 / Tempera on board / 12" x 16"
Still Life with Orange Bowl / 1965 / Tempera on board
 16" x 20"
Vermont Trees in Autumn / 1965 / Oil on canvas / 30" x 22" **128C**
Abstract Distraction / 1966
Bottle Series / 1966 / Oil 34" x 32"
The Bottles / 1966 / Oil on canvas / 34" x 32" **140C**
Bottles II / 1966-67 / Oil on canvas / 52" x 38" **2C**
Bottles — Blue Red Orange / 1966-67 / Oil on canvas / 32" x 34"
City Phantasy, Moon Over New York / ca 1966 **126C**
Convocation / 1966 / Oil on canvas **141C**
Experimental Landscape / ca 1966 / Oil / 26" x 40"
Farm Landscape, Vermont / 1966 / Oil on canvas / 24" x 36"
Flower and Blue Vase / 1966 / 52" x 38"
Half-seated Nude in Interior / 1966 / Oil on canvas
 51" x 38" **127C**
Imaginary Mountain / 1966 / Oil
Landscape, Vermont / ca 1966 / Oil on canvas / 24" x 36"
Lighted City / 1966 / Oil / 26" x 40"
Meadow Trees / 1966 / 40" x 50"
Moon and Planet Fantasy / 1966 / Oil / 20" x 24"
Moon Over New York / 1966 / Oil / 26" x 40" **139C**
Panel of Color Shapes / 1966 / 50" x 18"
People / 1966 / Gouache / 20" x 14½" **110C**
Sea of Tranquility / 1966 / Oil on canvas / 40" x 50"
Still Life, Fruit and Flowers / 1966 / Tempera on board
 12" x 16" **131C**
Still Life, Orange Series / 1966 / Tempera on board
 12" x 16"
Still Life, Red Apple / 1966 / Tempera on board / 16" x 26"
Still Life with Blue Vase / 1966 / Oil on canvas / 52" x 38" **6C**
Studio Medley / 1966 / Oil on canvas / 46" x 26"
Trees in a Field / 1966 / Oil on canvas / 40" x 50" **132C**
Trees in a Vermont Vale / 1966 / Oil on canvas / 30" x 33" **114C**
Abstract Landscape / 1967 / Drawing / 17" x 28"
Abstract Landscape — Vermont, U.S.A. / 1967 / Drawing
 19" x 26½"
Amusing Semi-nude / 1967 / Acrylic on canvas **134C**
Big Flowers and Bird / 1967-68 / Acrylic on canvas
 36" x 52" **136C**
Bottles II / 1967 / Oil on canvas / 52" x 38"
Bottles IV / 1967 / Oil on canvas / 34" x 32"
The Bottles V / 1967 / Oil on canvas / 34" x 32"
Dawn Landscape / 1967 / Oil on canvas / 24" x 34"
Duneland Landscape / 1967 / Oil
Dynamic Call / 1967 / Oil on canvas / 39" x 37"
Feminine Situation / 1967 / Acrylic on canvas **134C**
Figure Contemplating Still Life / 1967 / Oil on canvas / 38" x 51"
Garden Reverie / 1967 / Oil on canvas **4C**
Gretchen with Guitar / 1967 / Oil on board / 24" x 20"

New York City Landscape / 1967 / 45" x 50"
Pale Sun Over Vermont / 1967 / Oil on canvas / 26" x 26" **135C**
Pale Sun Over Vermont II / 1967 / Oil on canvas / 25" x 28" **138C**
Palette on Glass / 1967 / Oil ii-iiiC
Pink Sun Over Dreamland / 1967-68 / Oil on canvas / 24" x 31"
Posed Seated Figure / 1967 / Oil on canvas **133**
Rice Farm / 1967 / Oil on canvas / 20" x 24" **137C**
Seated Nude / 1967 / 46" x 36"
Still Life / ca 1967 / Oil on board / 24" x 48"
Still Life, Flowers on Green Table / 1967 / Oil on canvas
 32" x 25" **117**
Still Life, Orange Bowl / 1967 / Tempera on board / 16" x 20"
Still Life with Red Flower / 1967 / Oil on board / 24" x 48" **5C**
Sunday Painter / 1967 / Pen and ink / 24" x 18"
Tulips on a Green Table / 1967 / Oil on canvas / 32" x 25"
Abstract Vista / 1968 / Oil on canvas / 36" x 24"
Beach with Birds / 1968 / Oil on board / 18" x 12" **129**
Bouquet on a Garden Table / 1968 / 28" x 32"
Colour Stripes / 1968 / Acrylic on canvas
Deep City / 1968 / Oil on canvas **137C**
Figures by the Sound / 1968 / Oil on canvas
Homage to de Stael / 1968 / Oil on canvas
Last Experiments / 1968-69 / Oil on canvas / 31" x 48½"
Meadow Phantasy / 1968 / 29" x 50"
Pilgrimage by the Sea / 1968 / Oil on canvas **126**
Polynesian Festival / 1968 / Oil and tempera on canvas
 50" x 34"
Sea Realm / 1968 / Oil on canvas
Still Life / 1968 / Oil on canvas / 31" x 50"
Street Medley, New York / 1968 / Oil on canvas / 18" x 36" **139C**
Studio Exp. with Dynamic Forms / 1968 / Oil on canvas
 44" x 31½"
Studio Vista / 1968 / Oil on canvas / 50" x 48"
Studio Vista III / 1968 / 48" x 51"
Three Figures / 1968 / Oil on canvas
Young Mother and Daughter / 1968 / Oil on canvas **143C**
Blue Vase with Flowers / 1969 / Oil on canvas / 30" x 20" **6C**
Dynamic Shapes / 1969 / 36" x 28"
Fantastic Landscape / 1969 / Oil on canvas / 36" x 24"
Flowers Against Abstract Shapes / 1969 / Oil on canvas
 30" x 24" **2C**
Reclining Nude / 1969-70 / Oil on canvas / 40½" x 50½" **132C**
Seated Woman / 1969 / Oil on canvas / 34" x 24" **133**
Seated Woman II / 1969 / Oil on canvas / 32" x 26" **7C**
Studio on 25th Street / 1969 / Oil on canvas / 38" x 49" **3C**
Three Figures Conferring / 1969 / Oil on canvas / 52" x 55"

Undated Paintings

in alphabetical order

Abstraction, Sun Series **6C**
Bottles on Red Ground / Oil **125C**
Cape Cod Landscape / Oil / 16" x 20"
Ceramic and Leaf / Oil on canvas / 30" x 24"
Colour Photograph of Spanish Hat / 14" x 11"
Double Sun Over Earth **142C**
Figure at Window, Watova Road with Piano / Oil on canvas
Flowers in Blue Vase
Gretchen Contemplative / Oil on board / 24" x 20"
Landscape / Watercolor / 11½" x 17¼" **33**
Late Abstract / Oil **4C**
New Zealand Foothills / Oil on canvas / 16" x 20"
The Old Union Station / Tempera on cardboard / 21" x 28"
Orange Sun Over Sea / Acrylic on canvas / 44" x 30"
Red Anemones / Oil / 19" x 12"
Sea of Tranquility / Oil on canvas / 50" x 40"
Seated Nude / Oil on canvas / 17½" x 13"
Studio Interior / Crayon
Urban Vista / Oil on canvas
Vase on Green and White Striped Cloth / Oil / 20" x 16"
Vermont Landscape Rhythms **101C**
Woman Arranging Flowers and Interior with Two Figures
Woman Seated at Small Table / Oil on canvas / 25" x 32"

DATE DUE

GAYLORD PRINTED IN U.S.A.